THE
WATERCOLOURIST'S
GARDEN

THE WATERCOLOURIST'S GARDEN

JILL BAYS

David & Charles

FOR BERNARD

ACKNOWLEDGEMENTS

My thanks to everyone who has encouraged me. First to my family: to Bernard who has taught me such a lot about painting, to Caroline who assisted me and to Georgina and Roman. I would like to thank everyone who allowed me to paint in their gardens, to Pamela, Margaret and Lou. Especial thanks go to Eileen Hiner for her superb typing, attention to detail, help and patience. Thanks to Alison Elks my editor, to Brenda Morrison the designer, Leo Wilkingson my photographer, and to Faith who initially helped me. Lastly, thanks to all the friends I have made while teaching, for their enthusiasm and ideas.

A DAVID & CHARLES BOOK
Copyright © Jill Bays 1993
First published 1993

Jill Bays has asserted her right to be identified
as author of this work in accordance with the Copyright, Designs
and Patents Act 1988.

British Library Cataloguing in Publication Data
A catalogue record for this book is available from the British
Library.

ISBN 0 7153 9948 9

Typeset by ABM Typographics Ltd
and printed in Hong Kong
by Wing King Tong Co Ltd
for David & Charles
Brunel House Newton Abbot Devon

CONTENTS

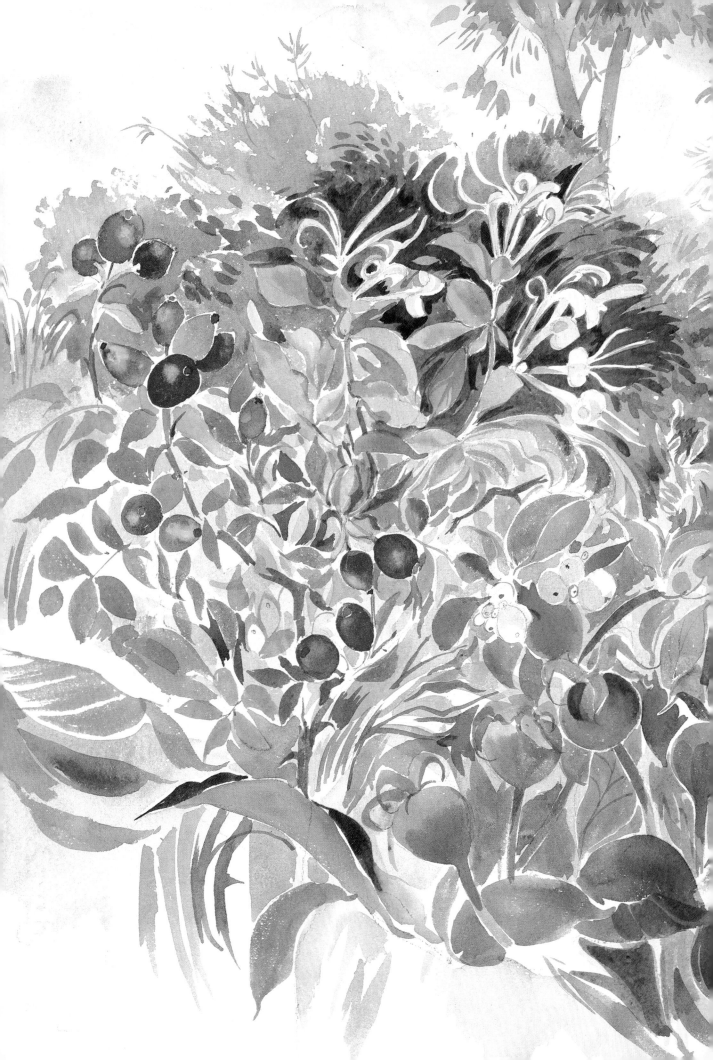

INTRODUCTION

Gardens are delightful places and have provided artists with subject matter throughout the centuries. My own garden is a continuing source of material – I look forward to the spring when the bulbs I planted in the autumn bloom, and the excitement of daffodils on a windy day makes me rush to find my paints. Spring is just a prelude to summer, which is overwhelming in its choice of colour and subject, while autumn makes you gasp. For artists, winter is never a dull time. If you miss a particular subject one year, you can be ready the next – as a gardener and plant lover, you can plan ahead. You can not only grow flowers, but you can show your delight in painting them.

Flowers have always fascinated artists. Examples of the use of the flower as a motif can be seen in the decoration of early pottery, and in Egyptian and Roman wall painting. Medieval manuscripts showed flowers both as symbol and decoration. Renaissance painting fascinates us by its truth to detail and the many and varied representations of flowers. What could be more natural than for the Impressionists to paint flowers? Pissarro's orchards or Monet's water garden never fail to delight us. The perfect shapes, the marvellous colour, the wonder and beauty of nature is encapsulated in flowers. Everyone can appreciate and understand them. The gradual opening of a bud, the full beauty of a bloom at its height, its fading and its ripening to a seed, is a process which, while complicated, is usually exciting. Whichever season is upon us, plants, flowers and seeds are available for us to examine, to draw and to paint.

My aim in writing this book is to make you aware of the possibilities that each part of the year provides for artists, and to enable you to record and recall some of the delightful forms and shapes we have around us. To me, watercolour perfectly captures the fresh and transient qualities of flowers and fruit. To be able to do this, we have to know what our paints and brushes can do, and what our colours can achieve. We have to research and study and have a confidence in our ability. I hope to give you a stimulus in providing ideas, and also to show you ways in which you can represent the exciting wealth of subject matter that the seasons provide.

MATERIALS

Many artists seem to work in the midst of muddle. Some produce the most exquisite work in awful conditions. The way in which artists work necessitates what seems to the uninitiated a fearful mess. Room and space are important, with plenty of areas to put old sketches and paintings. Keep plenty of reference material and file it if you have time. Keep those old vases and dried seed-heads. Your room should be a haven for you alone, but if you do not have this luxury, a tea-trolley can be very useful and has the advantage of being movable.

Many amateur artists are not fortunate enough to have a room of their own; if this is the case, don't give up! Paper can be kept flat in an old case and your materials will happily go into a medium-sized bag. A table with your board resting on a book suffices as an easel. One advantage in having your materials in a bag is that you are always ready to paint – if it's a lovely day, everything is at hand and you need not hesitate about taking your materials and painting outdoors. Having your materials so readily to hand can positively push you into painting – there are absolutely no reasons why you should not start.

There are few dos and don'ts about materials, but do keep your water (two pots preferably) clean and wash out the mixing area in your palette. Keep your paper flat and dust free. Don't keep your precious watercolours by a radiator or they will harden. Keep your brushes clean, and try not to leave them in water too long.

The materials you will require, as shown in the photograph, are not numerous – simply a palette, brushes, water, paper, board. A piece of rag is useful, as are paper-tissues; blotting-paper is a must. For outside working, a portable easel can be dispensed with, but a stool to sit on is essential, particularly in damp weather – but don't overload yourself.

BRUSHES AND TOOLS

Your brush is important and it pays to have the best. While there are pots in my studio full of brushes, only a few are used. My basic brush is a No 8 sable Kolinsky hair. It is resilient and goes into a fine point. It holds a good wash and can be used on its own or in conjunction with others.

A No 3 sable is useful for fine work, as is a rigger. A ¾in wash brush and a hake (lightweight goat's hair and wooden handle) are my basic equipment. From time to time I also use a stiffish paste brush for textural effects, and a flat-ended 'one-stroke' brush.

There are many different brushes on the market, often in synthetic fibre – the main thing to look for is a good point and the ability to hold water. A good quality brush in a large size with a good point can be sufficient on its own. Different kinds of water-soluble pencils are also available – all have particular uses.

Other equipment besides brushes can be seen in the photograph; most are useful at some time or another.

Pen with a steel nib This is useful for extra detail and can be used either with ink or with watercolour itself for that extra bit of detail that is sometimes needed – for example, fine branches or delicate stamens.

A swan's feather The quill end can be used for drawing and the feather part for texture. I often pick feathers up when I am walking by the river.

Sharpened bamboo Use for drawing – on its own it has a calligraphic quality. A similar instrument would be a reed pen or any kind of sharpened stick.

Razor blade, knife or scalpel Use for sharpening pencils, cutting masks, scratching out. Never be without a decent knife.

Sponge This can be used for damping paper and washing out, and also for making certain kinds of marks on the paper. It need not be large.

Blotting-paper has endless uses, from blotting excess water to creating lines or shapes, either in a positive or negative way.

Toothbrush for textural effects. Not to be used to excess, but useful for the odd piece of spatter or random dots.

Art masking fluid is a resist liquid which is used when you need fine lines or small shapes in a light colour, which would be tedious to paint around.

Candle A white candle can be used for larger resist areas, but you can't paint over it.

Hair-dryer A useful piece of equipment in the studio for drying washes quickly. A fire sometimes scorches, so beware.

Short pieces of card can be used as a printing instrument for stamens, stalks, etc.

A viewfinder such as an empty slide-holder is useful when determining your composition.

Other equipment such as scissors, steel rule and pencils are essential.

Uses of some of these items are explained in the section on handling paint (see pp28–31).

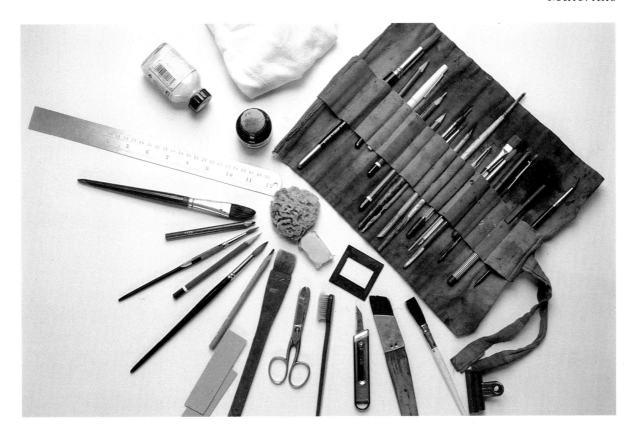

PALETTES AND PAINT

Certain palettes are useful for different kinds and sizes of work, and for different locations. The larger the mixing areas the better. Generally, I fill my palette with paint each time it is used and add to the colour that is already there. The palette wells are kept clean and ready for use. My studio contains various plates and saucers as well. A small folded paper palette can be most useful in an emergency and is easily made.

Paint

Watercolour paint consists of gum, glycerin, water, glucose, a wetting agent and preservative plus transparent pigment, which is mixed in the proper proportions. Very few people mix their own paint, but prefer to buy ready-mixed paint which is readily available in various grades. You can buy tubes, pans and cakes. There are artists grades and student grades in various sizes. Some colours are extremely expensive because of the rarity of the ingredients.

Colour can vary according to the manufacturer, but only slightly. Some colours stain paper more readily than others; some paint is more transparent and some more opaque. These qualities are best observed through use. Artists vary in their choice of colour, some swearing by one colour which another never uses. A basic palette is useful and one that can be added to easily. There are certain colours which are helpful to flower painters.

It is easy to get complacent about your palette. A change of colour can be inspiring and creative. It is best to start with a few colours of the best quality and to limit your palette to a basic few. My basic palette consists of: yellow ochre, raw sienna, raw umber, burnt sienna, burnt umber (these are earth colours), alizarin crimson, brown madder alizarin, winsor yellow, ultramarine, prussian blue, hooker's green dark. These eleven colours fill all my needs for general painting but when painting flowers I add: cadmium orange, aureolin, cadmium yellow pale, gamboge, permanent rose, rose madder genuine, magenta, winsor violet, winsor red, cobalt, cerulean, indigo.

Some ready-prepared boxes are over-equipped with colour, which for a beginner can be very confusing, especially if they are unlabelled.

Colours today are so well prepared that artists have few problems with them. Some colours may be more sticky than others, but if you replace caps and keep your paints in a cool place, they should keep well. (An artist I know keeps his paints in the refrigerator.) However, if your paint does become hard and apparently unusable, you can open the wrong end and use it with water. If you use pans, damp them first and this will soften the paint.

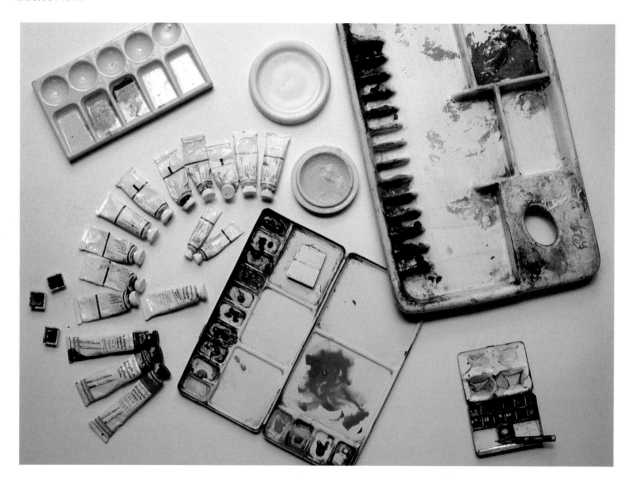

Supports

My favourite drawing-board is one that has survived many years; it takes a 15 × 20in (381 × 508mm) paper and is a general-purpose board. I also have a large Imperial board which fits on a folding easel and several smaller boards. It is useful to be well equipped with supports and to have several ready with stretched paper. A metal folding easel which can be tilted at an angle is very useful.

Although it is very nice to have different sorts of equipment – mine has built up over the years – don't forget that two kitchen chairs can serve the same purpose as an easel.

PAPER

Good paper is a joy to work on. It will take all kinds of application of colour and all kinds of punishment; you will be able to wash out or scratch a good paper. Cheap papers, on the other hand, have definite disadvantages. Always buy paper which is made especially for watercolour painting. Students can find paper which will suit their purse to start with, but be adventurous and try as many different kinds and weights as possible. If you are inhibited by cost, buy a lightweight paper and stretch it. Try

to get hold of sample sheets and try them out; it can be very annoying to find that you have a large sheet of paper with a surface you find difficult to work on. Some papers are very absorbent and take a lot of getting used to as they seem to soak up the paint. Good papers are watermarked – the side on which you can read the mark is the side to use. You can use the reverse side, but it may contain blemishes. Cheaper papers sometimes have an intriguing grain which can become rather monotonous.

Paper is available in different weights and with different surfaces, or finish. Rough paper has a coarse grain and is somewhat difficult to use – it is suited to broad paintings with little detail. Not Pressed (or Cold Pressed) has texture but is finer; it is ideal as a general-purpose paper. Hot Pressed has a smooth surface. It is good for small work, gouache line and wash, but washes are difficult to handle on this paper. The texture of paper is all important – the 'tooth' is valuable for brilliance and sparkle.

Paper is judged by the weight of a ream. Lightweight papers weigh 72lb or 90lb. A medium-weight paper is 140lb and is suitable for general use, but there are heavier papers weighing 200–300lb. These heavy papers are board-like and do

not need to be stretched. The whiteness of paper varies and some papers are available in various tints – grey or sand, for example.

Paper is one of the most important components of watercolour painting, so don't be tempted to make do, but suit your medium to your paper. Be prepared to experiment on different papers and try to foresee the different results that are possible. There are many kinds of paper for all sorts of purposes, so make sure that your paper is for watercolour use. Although some cartridge paper is best for sketching and drawing, it can take a certain amount of colour if it is lightly applied.

Paper is available in sheets, blocks and pads of various sizes. Blocks are useful for taking on holiday as you do not need to stretch the paper. After painting you slip a knife around the edge and release the paper. Paper bought in sheets is usually 30 × 22in (762 × 559mm) and often is known as Imperial size. Pads of watercolour paper can be useful, but many beginners buy very small sizes because they are timid and unless you use them for sketching or notes they can be very limiting. Students often condense the size of their image to suit the size of their paper. Be generous – large sheets can be cut and the back of the paper used.

Stretching Paper

It is often advisable to stretch paper under 140lb weight. Large sheets – that is, 15 × 20in (381 × 508mm), 140lb weight, are better stretched, but this can depend on your particular method of painting. Stretching provides a flat taut surface to work on and avoids cockling. It is easier to mount. Stretching is essential if you work very wet.

To stretch your paper, take four strips of brown paper gummed strip cut larger than the paper you are to stretch. Have your board ready. Submerge your paper in water for a few minutes until it is thoroughly wet (a bath or large sink will do). Take the paper out, let it drip for a second or so and place it on your board. Damp the sticky tape and tape the sides of the paper, smoothing out any wrinkles, and finally wipe off any excess moisture with a clean cloth. Dry flat. If your paper comes up you may not have gummed down the paper securely enough, or the tape may be defective, or you may not have dried the paper flat. When you have finished your painting, slip a knife underneath and remove it from the board. Sometimes I make absolutely sure that the paper is secure by also using a staple gun. If you have time, it is helpful to stretch several pieces of paper at the same time.

Henrii Lilies

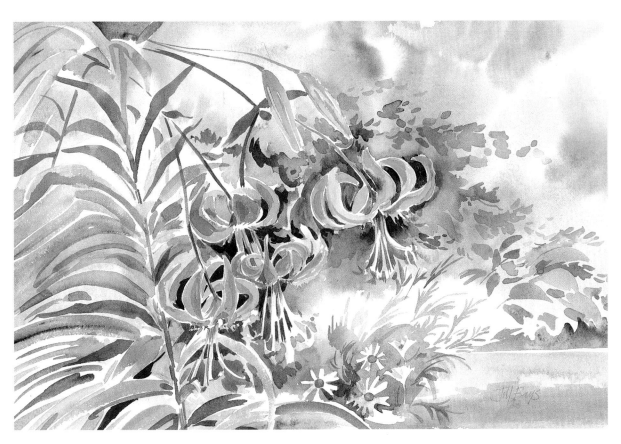

COLOUR

It takes time to know your colours, but the rewards are enormous. For instance, you must know the difference between burnt sienna, light red and brown madder. They look the same on the palette, but they are very different on paper. Each one when mixed with blue will make an entirely different grey. Watercolour is so immediate a medium that to obtain freshness and clarity it is imperative to know without hesitation which colour to use.

We can all recognise colours: blues, reds, yellows; we know the subdivisions of colour: light, dark, etc; and we know the varieties of blues: navy blue, bright blue and so on. It is difficult, however, to realise the tremendous variations that can appear. On close inspection, something which on the surface is murky and dark can reveal many subtle colours which are influenced by other colours, which in turn will give properties to adjacent surfaces.

When mixed, the three primary colours, red, yellow and blue, become the secondary colours, orange, green and purple. These secondary colours each have a complementary or contrasting colour which is the colour not contained in the mix – hence, red/green, yellow/purple and blue/orange. These colours when used simultaneously have an exciting effect. Colour which is further mixed, creating a wealth of subtle tones, is known as broken colour. However, when three colours are mixed together they can, in watercolour, appear dirty and muddy. Colour mixed on the paper is the brightest; if mixed in the palette it does not have the same brilliance. Overlaying primary colours achieves brilliances also.

Some artists swear by certain colours and have a preference for certain mixes, but it is up to each student to discover for him- or herself the colours which give the best results for them. It is easy to become complacent and lazy about colour – you can be very stimulated by looking at paintings and wondering just how the results were achieved. There is no formula for success.

PRIMARY COLOURS

Winsor red *Winsor yellow* *Permanent blue*

Winsor red + *Winsor yellow +* *Permanent blue +*
Winsor yellow *Permanent blue* *Winsor red*

Orange, green and purple as mixed on the palette

There are many different reds, yellows and blues. Experiment with various colours and remember the effects they create.

GREEN AND HOW TO ACHIEVE IT

When painting in watercolour you have to be sure of various colour mixes and because of this I prefer to work within a range of light, medium and dark greens. This can be quite simple and, with the addition of a warm or cool colour, you can achieve the green you want. It is possible to make satisfactory greens using mixtures of blue and yellow – for

DAFFODILS AND LEMONS
I was given this lovely iridescent vase with glass marbles inside it, so set up a still life. I bought the little daffodils and found foliage in the garden. The begonia with its delicate pink flowers and glossy dark leaves was a foil to the pale greens of the daffodil stalks, which made a fascinating study in themselves. The daffodils were so delicate and pale that they needed a darker ground, so I used a complementary colour – mauve used fairly strong to make a contrast. I was conscious of contrast all along – pinky-red to green and dark to light and yellow to purple-mauve

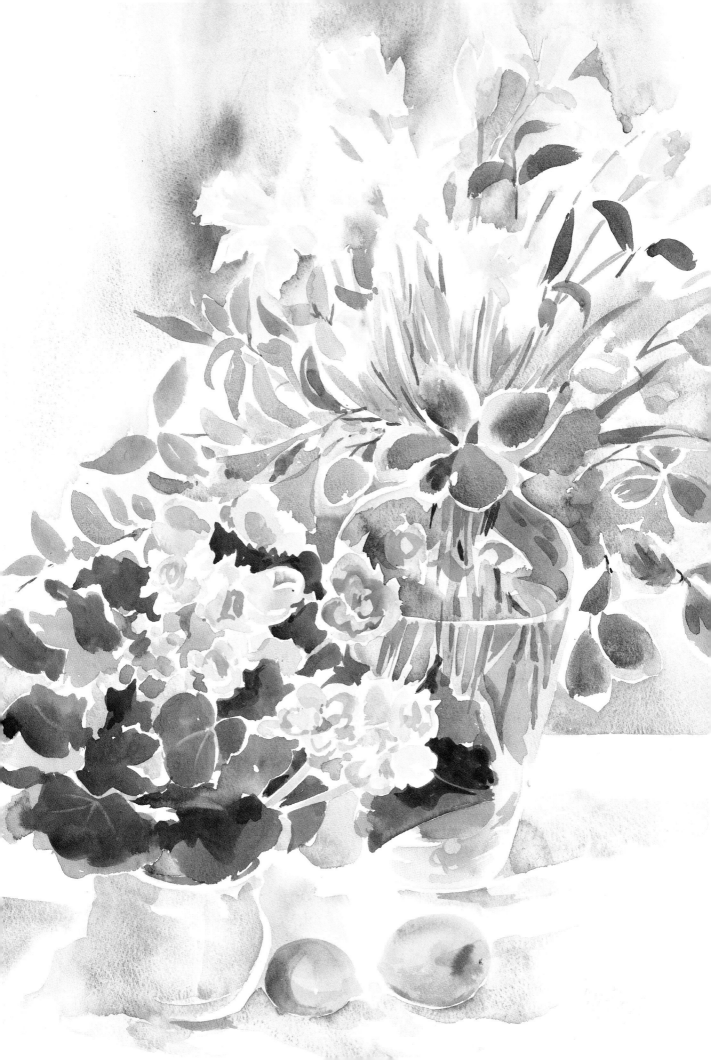

example, ultramarine and winsor yellow – and there are several variations. I tend to rely on hooker's green as a base, to which is added, according to the subject, raw sienna or yellow ochre or cadmium yellow – this is my light green. For a medium tone, burnt sienna is added to hooker's green. If your green is bluish, it can be adjusted accordingly, or if a warmer colour is needed, reds or browns can be added. For my darkest green, burnt sienna is added to prussian blue. Unfortunately, hooker's green stains the paper and is not easy to wash out.

MAKING GREYS

With practice, it is easy to know if the grey you want is warm or cool. Most blues and reds combined make certain sorts of grey, some more purple than others. Again, try out various mixes, using ultramarine or cobalt as a base, plus brown madder, burnt sienna or light red. Sometimes the shadows which appear on white flowers are extremely subtle and may have a tint of yellow or green in the grey. You have to look very hard indeed to see colour, to identify the exact tint you need.

A BASIC PALETTE

Winsor yellow, yellow ochre, raw umber, burnt sienna, brown madder, crimson alizarin, ultramarine, prussian blue and hooker's green. These nine colours make up my palette, but I keep by me various other colours which I use from time to time.

Blues: Cobalt, cerulean and indigo. Get to know the differences. Cobalt is a light clear blue, while cerulean is colder and greener. Indigo has rich dark qualities.

Pinks and reds: You will find that painting flowers often requires different pinks or reds. Some that are useful are rose madder genuine – a clear, cold pink; permanent rose – a rather intense pink to be used sparingly; mauve – useful for purple flowers, as is magenta. For a clear bright red, use winsor red.

Yellows: Additions to my palette are lemon yellow, cadmium yellow pale, aureolin, gamboge, raw sienna and cadmium orange. Lemon yellow is cool, cadmium is warm. Aureolin is a clear, clean, cool colour, and gamboge is warmer.

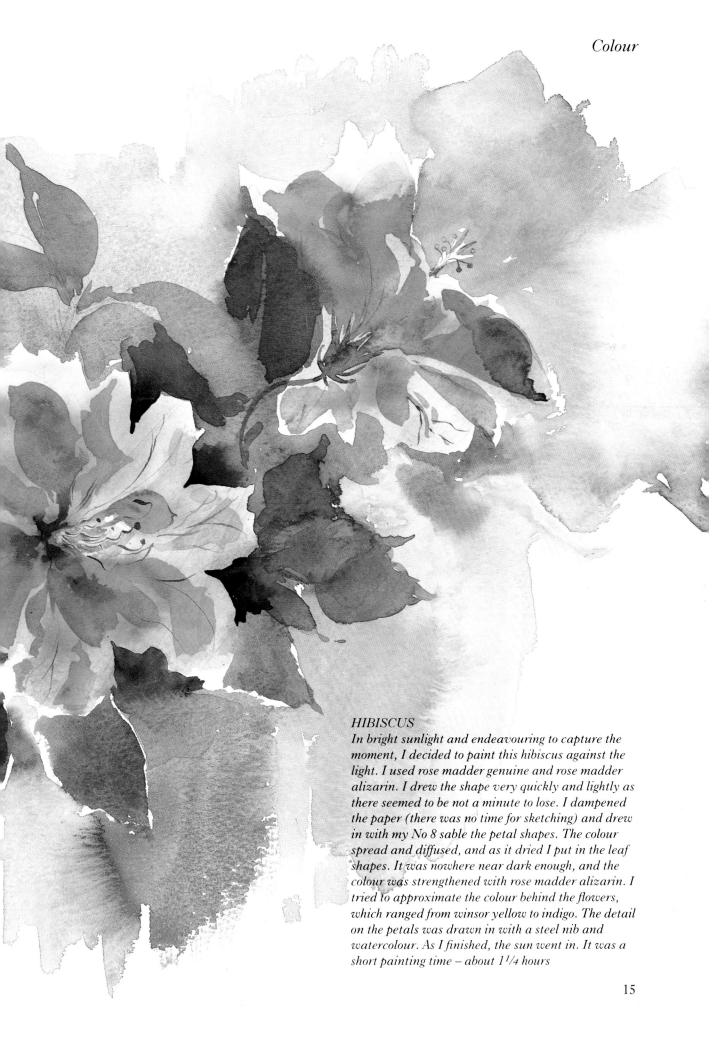

HIBISCUS
In bright sunlight and endeavouring to capture the moment, I decided to paint this hibiscus against the light. I used rose madder genuine and rose madder alizarin. I drew the shape very quickly and lightly as there seemed to be not a minute to lose. I dampened the paper (there was no time for sketching) and drew in with my No 8 sable the petal shapes. The colour spread and diffused, and as it dried I put in the leaf shapes. It was nowhere near dark enough, and the colour was strengthened with rose madder alizarin. I tried to approximate the colour behind the flowers, which ranged from winsor yellow to indigo. The detail on the petals was drawn in with a steel nib and watercolour. As I finished, the sun went in. It was a short painting time – about $1^1/4$ hours

15

COMPLEMENTARY COLOURS

The use of complementary colours can enhance the colour values of a painting. Mostly they have to be used consciously, and it is this conscious effort which can give a painting inspiration. You can decide if your garden needs a particularly sunny look to it and adjust your colour values so that they contain a greater proportion of, say, yellows and oranges, and knowing that the complementary colour of orange is blue, your colour scheme could be based on that. In the painting of the flowers in the glass vase, the colours were solely those achieved by using blue and its complementary orange, and the colours which made up the complementary – that is, red and yellow. This kind of exercise can be both informative and interesting and certainly will add to your knowledge of colour.

Red and its complementary green are striking, vivid colours, but used in excess can be too harsh and strident; both seem to need to be cooled off, as in the illustration of the poinsettia. It is probably better to use your complementary colours in a more subtle way and to use them as components in backgrounds or colour accents. In this way a harmonious result can be achieved.

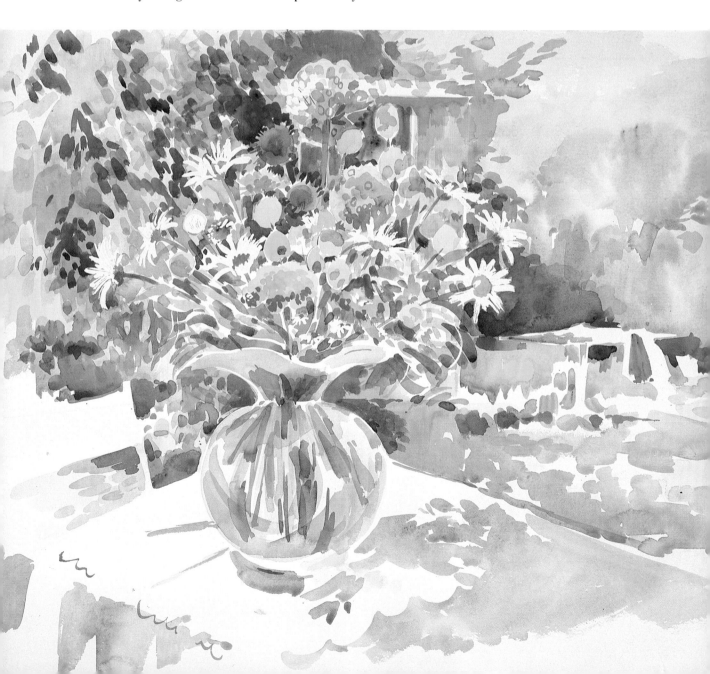

△ *POINSETTIA This Christmas plant is nature's clever way of using colour, but its vibrant complementaries could need toning down with some soft and cool greys in your composition*

◁ *NARCISSI The two complementaries here are yellow and purple, used in conjunction with other soft tints, the result being a restful, unified painting*

(opposite) SUMMER VASE A blue and orange painting: a deliberate exercise in using complementary colour to capture the feeling of a hot summer's day. The ultramarine blue could be termed a warm blue

17

DRAWING

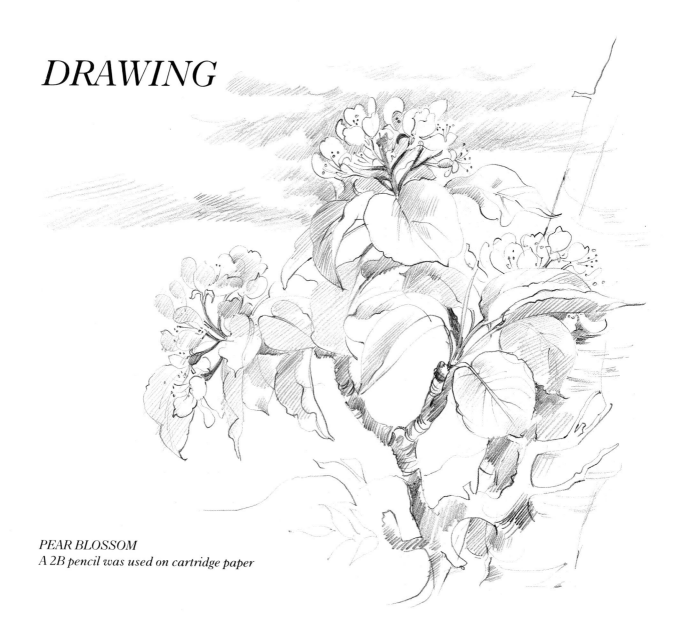

PEAR BLOSSOM
A 2B pencil was used on cartridge paper

There are many ways of drawing, just as there are many ways of painting. However experienced you are, there are times when careful drawing and practice are necessary. So with a medium soft pencil, perhaps a 2B well sharpened, look for the main shape and structure. Is it a cone, sphere or cylinder? How many petals are there? Do they overlap or spiral? What kind of leaves? How do they grow? There are many different leaf shapes – palmate and pinnate to name but two – and the arrangements of leaves on a stem can be important and it is a good idea to be aware of this. The way that flowers form on stems is useful to know, as are the individual parts of a flower. However, I am not supposing that you are a botanical artist, as botanical drawings must be extremely precise and must represent each part fully and accurately.

To most people drawing suggests pencil and paper, but the idea of drawing with a brush can help your confidence. Try using a No 3 sable and one colour, or perhaps ink diluted. It is easy to carry around. There are dangers in drawing with a pencil as a prelude to painting. If you press too heavily the paper can be scored and the line is difficult to rub out. Then there is the danger of just filling in the pencil areas when you paint, rather as children do on colouring books. Whichever way you find the best, it is of the utmost importance to be able to define the shape in such a way that the character of the flower is not lost.

There are many different ways to use a pencil. Presuming that you are starting off with a soft pencil sharpened in such a way that you can use its point as well as the side of the lead, you can achieve

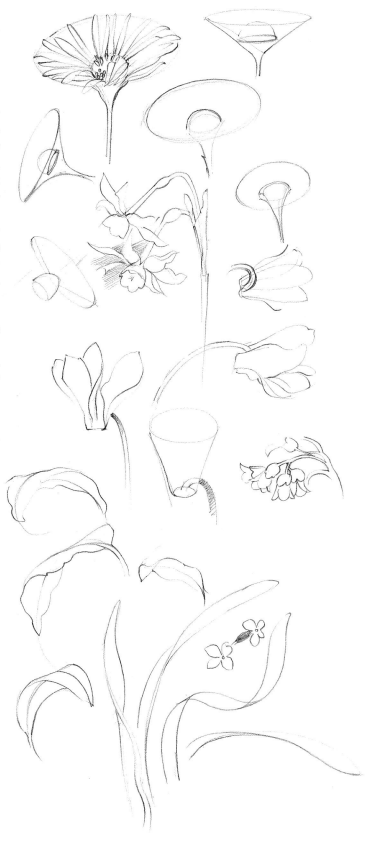

a variety of line from shading to detail work. If you practise using a pencil to create thick, thin, short or long lines, it will be an invaluable lesson to remember when you start drawing with a brush, which is, after all, painting. Mostly we forget what a pencil is capable of. A pencil, with you guiding it, should be able to define the form or shape of any object; it should be able to create texture and tone with the variety of marks that it can make. Drawing can be looked upon as a prelude to painting, or as a preparation for painting, so that when you start painting with watercolour, accurate drawing or representation is obvious to see.

When drawing, cultivate good habits. Use the edge of your paper as the vertical and get into the habit of using your pencil as a measure so that proportions are more or less correct. Other devices can help your drawing. A penknife, when open, is useful for comparing angles (as are two pieces of card). If you are skilled at drawing you won't need these bits of advice, but there is no doubt that good drawing is the basis of good painting. It does require a great deal of concentration – more than many people are prepared to give.

DORONICUM
These bright yellow daisy-like flowers appear in spring and bloom after daffodils. If you pick off the dead heads the plant sometimes blooms again in the autumn. Base the flower, like so many daisy shapes, on an ellipse

NARCISSI
This dwarf variety is very dainty with clear, light lemon-yellow flowers with several blooms to a stem. In drawing them you have to think of spheres and shortened cones

CYCLAMEN
There are many varieties of cyclamen. The one drawn here is a miniature, but its behaviour is like other more showy cyclamen; it resembles an upside-down cone spiralling out. The stem does not appear like the stems of other plants, as the petals are reversed

LEAVES
If you practise drawing ribbon of various widths in different ways – that is, curling and winding – you will have no difficulty in tackling curling leaves

REFERENCE AND SKETCH-BOOKS

Ideas are sometimes hard to come by and inspiration is essential. In summer a walk around the garden can be sufficient as nature is very generous, but there are other times when you will need a stimulus. A visit to any of the great museums or galleries can be the catalyst, but this is not always possible, so if you can build up your own reference library you will find it invaluable.

A scrapbook containing ideas and examples of work by other artists is very useful. Your own photographs can often be a starting point, but use them as a reference only; always prefer the real flower, the real situation. My photographs are kept in a small album with transparent leaves, but if I need various shots at the same time they are pasted up on a board so that no time is wasted looking up information. But above all, use a sketch-book. Use it to work out your ideas and your procedure. Use your sketch-book if you are not sure how to achieve certain effects – for example, the depth of colour needed – or to work out the drawing of a particular shape. Sketch-book ideas are useful for clarifying your thoughts. You can also use your sketch-book as an aide-memoire. In sketch-books you can be free, private and unfettered. Whether or not you develop your ideas and sketches does not really matter; it is important to put your thoughts down, to make decisions, and at the same time to become more familiar with your brush or pencil.

I use various sketch-books and have several on the go at the same time. There are pocket sketch-books – A6, A5 and the larger A4 books; some have cartridge paper, some have smooth paper and there are watercolour sketch-books of various sizes. The one I use mostly contains Bockingford paper and is spiral bound, but a good cartridge paper sketch-book will take light washes. A larger (A3) water-

colour block or sketch-book is useful when you are on holiday. There are books which have hard backs to protect your work and are unobtrusive if they are carried around.

Many lovely books are available on gardens which can give you ideas – even seed catalogues can be inspiring. But always prefer the real thing and let nature be your guide. Even if you live in the heart of a city, make sure that you are friendly with your local florist or park-keeper, or, if you live in the country without easy access to libraries or museums, you can always study the hedgerows for ideas.

Sometimes your sketches may be more interesting than your more considered work; a sketch-book can make you feel more free. Sketching can fill in odd moments – for example, while you are waiting at an airport or station. Whatever you draw, the practice is never wasted and your powers of observation are heightened.

USING PHOTOGRAPHS

Painting in front of the subject is not always possible, and unless you have prepared the right kind of reference in your sketch-book or are possessed with a photographic memory, it is difficult to be creative from nothing. So photography can be useful if used in the right way, as an aide-memoire. My photographs are often reminders of a subject already painted, or a subject I would like to paint, and very occasionally they are useful as starting points for compositions, or they might just provide the inspiration needed. Sometimes they are useful for detail, if they are sharp and defined; if they are blurred and out-of-focus they may provide the feeling I am trying to achieve. My camera is a small semi-automatic 35mm and slips comfortably into my sketching bag.

COMPOSITION

Often the natural arrangement you are confronted with can be sufficient to give your painting credibility. Flowers, stalks, stems and leaves have a pleasant way of arranging themselves. There are so many aspects to capture: the fragility of petals in a certain sort of condition; the day could be still and hot, or there could be a wind blowing with the hint of a storm. The contrast of pale pink poppies against the indigo blue of a thundery sky leaves no one in doubt about colour contrast.

There are various devices which help the artist to compose a picture: looking through doorways or windows is intriguing, and paths can wind up to your focal point. Darker shapes in the foreground and unusual viewpoints can both be used to advantage. Consciously try to avoid cutting the painting in half either horizontally or vertically. Difficult backgrounds can be avoided by flattening the picture plane.

It is all too easy to sit down in front of your subject with a sigh and start, only to find that a slightly different viewpoint can alter the format quite drastically for the better. So, if you can remember, take plenty of time to plan your picture. This is

COMPOSITIONAL SKETCHES
Wherever I am painting (indoors or out) I usually try to make thumb-nail sketches of my subject. These have two purposes; the first enables me to analyse my subject and the second breaks me in easily to the idea of painting – these sketches help to clarify my thoughts. Sometimes I use a viewfinder (an empty slide-holder or a piece of card with a rectangle cut out, or my hand) which eliminates unnecessary material. My initial sketch can be cropped or the format changed; it can indicate tone and sometimes colour. It is indispensable. Different viewpoints and different arrangements can be explored

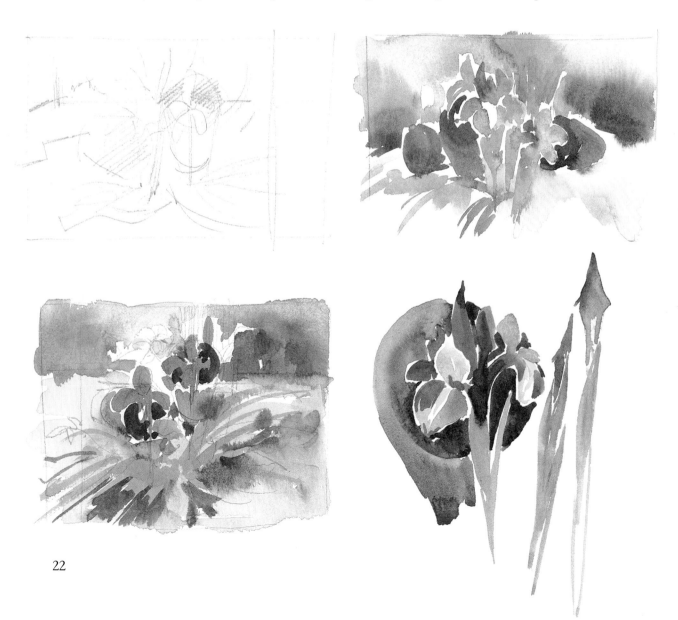

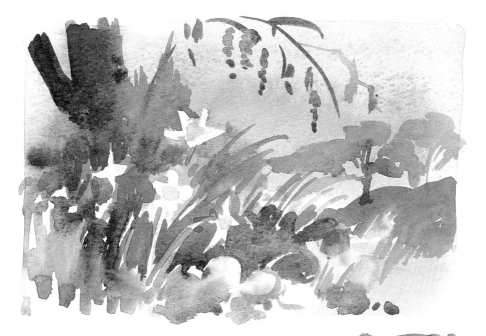

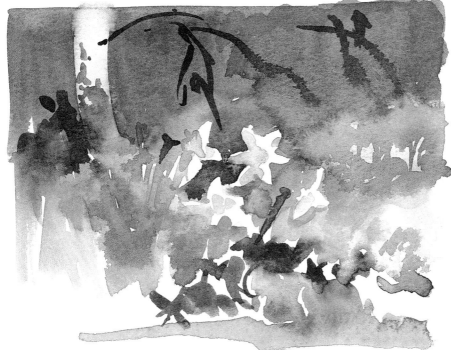

*THUMB-NAIL
SKETCHES
These two thumb-nail
sketches show two
different approaches to
the same subject. The
composition is the same
in both, but the colour
schemes change to give
a different look to each.
This composition was
arrived at in the studio
and a still life was set
up using a log for the
tree and various
grasses, dried leaves,
etc with a few spring
flowers. The background
was borrowed from a
landscape. A pencil
sketch was made
originally, followed by
the two colour sketches.
Sometimes I would
accompany these with
colour swatches for
flowers, and perhaps a
more detailed painting
of individual items
which might prove
difficult*

difficult when you long to start painting, but it is worthwhile. Often the subject itself is sufficient, but if you are undecided, spend extra time on the preliminary stages.

Occasionally (when your painting is completed), you can change the composition by masking or cropping, but be careful or you may crop the painting so much that it disappears altogether. Paintings often look pleasant if they are vignetted – that is, with no definite edge, just fading off into the white paper. Two or more attempts at the same subject often pays off, as you can realise halfway through that something isn't quite right. Many artists change their minds by adding or subtracting and even repeating work until they feel it is right. Your composition may be influenced by other factors, by how you feel about a subject or by how you feel physically. Do you paint better with soft music? Are you more inventive in the morning or does inspiration wait until the evening? Some artists find that their paintings take on a new life when the size is changed, not only from small to large or vice versa, but from square to long and narrow, upright to horizontal. Maybe difficulties can be overcome by thinking in a different way, as we are too used to following the same old routes.

PERSPECTIVE

The word perspective can strike terror into some art students. However, rather than ignore it altogether, it is a good idea to be aware of certain aspects which can affect your drawing. Always try to draw what you see as faithfully as possible. If it looks incorrect, check every aspect – your eye level, verticals, horizontals, any directional lines, angles, negative spaces, etc. If you are still in doubt, check your perspective.

Try to work within your sight range – use a viewfinder if necessary. Work with your paper pinned square on your board and avoid working at an angle. It can be useful to make some indication of scale in your work, perhaps the portrayal of large to small shapes – contrast is always interesting.

Objects in the distance appear smaller than the same object near to you. These objects vanish on the horizon, which is your eye level. The point where they vanish is called the vanishing point. There are several ways of illustrating this. Let

us take single-point perspective, which is ideally illustrated in my mind by standing in the middle of a long straight road in France. The edges of the road narrow and vanish on the horizon, as do the trees at the side of the road.

If an object with flat planes such as a box is placed at an angle to you, the edges of the box will recede away to two different points on the horizon, creating two-point perspective. You can have many different vanishing points and obviously an object will look different when viewed from differing eye levels, so be aware that you could be looking down or up at your subject.

Ellipses often present difficulties. Remember that when drawing a round object the ellipse goes around the back. Drawing glass is a good exercise, and careful observation pays dividends. When drawing a vase, remember that the ellipse at the top will be slightly different from that at the bottom, and that any pattern will also go around the vase.

If you wish, there are other ways of portraying objects which are not so involved with the straightforward rules of perspective. You can flatten the picture plane and ignore perspective, or

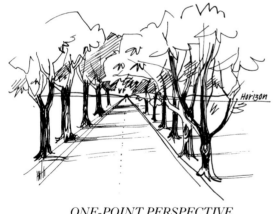

ONE-POINT PERSPECTIVE

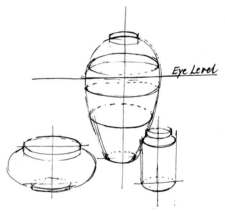

ELLIPSES
When drawing a vase or flower container, try to construct it with a vertical and be aware of your eye level

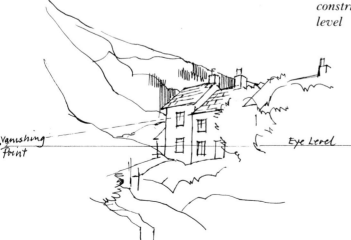

COTTAGES ON A HILLSIDE
Besides knowing approximately where your vanishing point is, remember that hills and distant trees and sky can also give a feeling of distance to your painting, and that tone and colour can play a big part

you can, as in wide-angled photography, take in more than your eye can actually see. You can distort and put different perspectives into your painting, as if you are looking into a fish-bowl.

Perspective can be used in various ways to enhance your composition. It can be used in a subtle and indirect way to create a feeling of distance, much in the same way that colour can make an object in the foreground more prominent. In painting three-dimensional objects on a flat plane, you have to use various devices to make something look more or less real, and with landscape painting you should get the perspective right or your painting will always look slightly odd.

PERSPECTIVE ILLUSTRATED

I am hoping that this painting will illustrate not only the use of perspective, but the need for perspective in painting gardens. The picture shows a corner of a neighbour's bungalow and French windows, with a balcony above. I felt that the perspective was illustrated very well here. You had

to have a knowledge of perspective in order to get the lines of the window and the balcony right. I was sitting quite close to it – perhaps slightly too close (it was rather difficult to get farther away) – so that my eye level was, in fact, about on the windowsill. I drew the whole situation in pencil first, as it was quite difficult to do. I used a ruler to help me. I was aware that my vanishing point was somewhere off the page, but apart from that I tried to concentrate on what I could see in front of me. A good help when trying to get accurate angles is to have a piece of card, or a penknife, which you can use as an angle – you can hold it up to your subject and then down on your painting, which helps to give you a more accurate angle. It's not foolproof, but it is an aid.

Having drawn the scene, I painted the light greens first – all the lightest tones that I could find – and then added more and more colour, until I was painting the darkest tones, which brought out the light tone. The building was slightly in the shade as the sun came around to the west, and the leaves of the variegated ivy just caught the sun.

WORKING OUTSIDE ON LOCATION

There is nothing more pleasant than painting outside on a warm spring or summer's day. Subjects are all around you. You have only to decide on a particular place to be and before you know it, you are happily painting.

However, it is not quite so simple. Presuming that you have already picked your subject and know that the morning or afternoon light is best, you will need to ask yourself a few questions. Are you well equipped and comfortable? Will you stand or sit? Do you need an easel? Have you remembered your water bottle?

One artist I know has a check-list in his studio, which he goes through before filling his bag. My fishing bag is waterproof and has two large pockets; it is large enough to take a small board, paper and folding stool, as well as my minimum equipment, which consists of the following items: small plastic water bottle; plastic water pot; slim palette; box of paints; roll of brushes and pencils; sponge, ink and blotting-paper; sketch-book; camera. I also take a folding easel. You may well need a hat, mosquito cream and an extra sweater.

Make your painting procedure as comfortable as

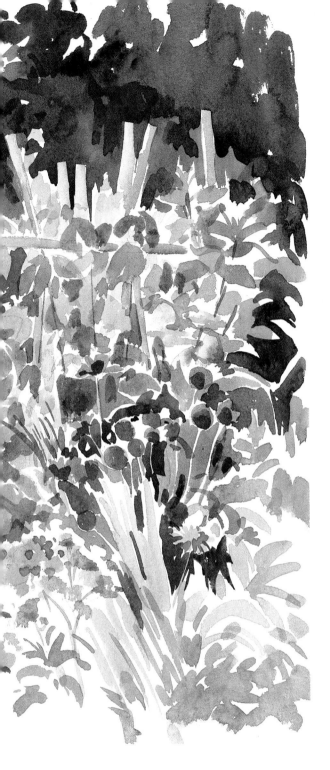

outside, however, it is more complicated. So many things can change: your original viewpoint – you decide to sit, having viewed your composition from a standing position – and something that you hadn't noticed before suddenly comes into the picture. This is supposing that you are a good judge of what makes a successful composition, and that you have some idea of what looks pleasing or alternatively jarring. If you decide on a subject, but find that something doesn't quite work, try turning 45° – it sometimes works. If you move components around, often things don't work out or you just get lost. Watercolour is such an immediate medium that you can't correct mistakes easily, particularly on location. In the studio, where you have access to a sink, a certain amount of washing out can take place, but unless you have a good stout paper, the surface can be disturbed. It can be exciting to correct and get right something you had given up on!

When painting in the garden, it is very easy to get bogged down by detail, but by using colour masses and directional shapes, you can achieve a harmony even though your subject seems to be confusing. Simplification is essential. You can start by simplifying the general colour areas – certainly background areas – putting more detail and emphasis where you think it is necessary. With a summer garden and a mass of colour, a focal point should be chosen – this is easier when painting a few flowers in a bowl – but in the garden choices have to be made. Artists sometimes refer to the focal point in a flower composition as the 'star' or 'ballerina'. This need not be central. Most arrangements or compositions need a focal emphasis of some kind.

SIZE

Some students are often concerned with the size of their work. There are no rules, but if working small, say 6 × 4in, (152 × 102mm), gives you confidence, that's fine. If you can handle working larger, say 15 × 20in, (381 × 508mm), go ahead. It is exciting to work large and it can increase your enthusiasm. If you feel in need of a change or are stale, try working in a different size, or on different paper, or in a different way – gouache on grey paper, for instance; variety is good. Whatever size you work, use the largest brush you can handle. Some flowers – for example, honeysuckle – are obviously small and delicate and need to be treated with care and thought, but endeavour to treat your work broadly and throw away those small size brushes.

possible. If you are right-handed, have your materials to the right, and vice versa, so that you don't have to reach too far for your water, etc.

COMPOSITION IN THE GARDEN

It is very pleasant and convenient to find exactly the right composition. More often than not you are lucky, and with some moving around, some small repositioning, you are settled and can begin. With still life or indoor subjects, getting everything right takes a little time, but it can be done; when you are

HANDLING PAINT

You can always find new ways of using paint, but there are certain basic techniques which are useful to know and become proficient in. The way you use paint must become second nature. Be prepared to put your paint brush to paper and to paint anything that captures your eye. Before you realise it, like learning to ride a bicycle, you will be away.

A FLAT WASH

A wash is the most basic of techniques; it can be used for small and large areas. Suit the size of your brush to the area needed, but always try to use one larger than you think you need. You will require a sufficient amount of colour to cover the area needed – this is invariably more than you think. Mix more than you need and mix thoroughly. Tilt the board slightly and with a fairly loaded brush work quickly from left to right. If it is a small area, use as few strokes as possible to cover the area. If the wash is shiny wet it can be manipulated, but if not leave it alone and don't be tempted to touch it up.

GRADATED WASH

This wash goes from dark to light. Start with a full brush and gradually add more water until the wash gets paler and paler. Your board can be tipped or tilted to allow the wash to run freely. With these flat washes it can be useful to damp the paper before starting. Sometimes it is easier to work if you move your paper or board around – that is, work from the top or sides. It is useful and good practice to fix your paper to your drawing-board by pins or tape and to be aware of the vertical side of your board. Once acquired, good habits are not easily forgotten.

COLOUR GRADATED WASH

A colour gradated wash is very similar to the basic wash, except that two or more colours are mixed on the paper to form a gradual gradation from one to the other. Prepare your washes first and with a clean brush, brush into the first wash to make a clean transition from one to the other. You can use this in large or small areas. It is similar to the wet-into-wet technique.

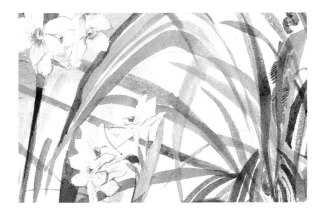

BRUSH STROKES

Different brushes make different marks, so become familiar with each of your brushes and know what kind of mark they are capable of. Your line should be versatile and be able to vary from floppy to taut. The more drawing you do with your brushes, the more used to it you will be. Practise long flowing lines and short staccato marks. Hold your brush in different ways and find out if it makes a different mark. Using a dry brush can make interesting marks.

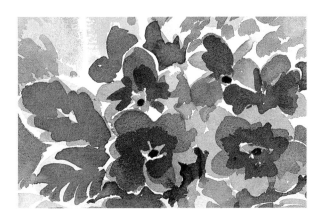

OVERLAYING SHAPES

The most delicate effects can be achieved by overlaying washes of pure colour, especially primary colours. Apply one wash and let it dry thoroughly before applying the next. The pure colour will glow with an intensity that mixed colour never achieves.

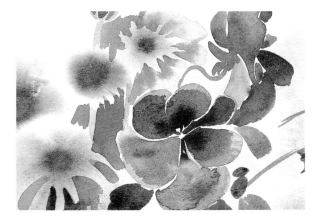

DAMP PAPER

The most beautiful soft effects can be achieved by working on damp paper which has been stretched. If you drop colour on to damp paper it will run and suffuse; the density of the colour can then be increased where needed. It is great fun to paint imaginary flowers this way and you can achieve a fairytale effect. The paper will dry and you have to be prepared for the colour intensity to diminish, but working this way teaches you a great deal about colour and how much paint you may need.

William Turner often worked very wet. He would stretch his paper on boards and 'after plunging them into water, he would drop the colour on whilst it was wet, making marblings and gradations throughout the work'. He would use this background to work on. Incidentally, in Turner's watercolour box, he had 6 distinct yellows, but only 4 reds, 4 browns, and only 2 blues and 2 greens.

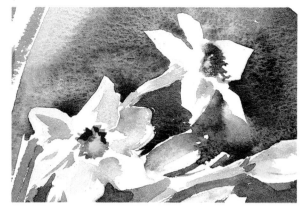

LEAVING WHITE SHAPES

Your paper is your lightest colour – that is, white – so that to paint a white flower you paint around the edges. There are several ways of doing this. You can draw your flower very lightly first, then with clean water wet the area outside the flower and drop the colour in – the water should carry the colour. Alternatively, you can paint directly around the flower. You may find it easier to limit the area as you have to work fairly rapidly to keep the paint flowing. When your exterior washes are dry, you can then indicate tones and shadows on the flower. Some artists prefer to use masking fluid, but sometimes this can lead to a hard edge – it rather depends on the size of the shape.

HARD AND SOFT EDGES

Some of the most exciting features of watercolour painting are the contrasts of different paint application. I am referring now to hard and soft edges. Sometimes this is accidental, but often the most exciting effects are consciously obtained. The edge of a flower which is near to you may be hard and the further edges soft. Shapes in the background may be blurred and contrast with the harder edges of certain leaves. Areas can be softened by blotting and sponging.

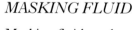

MASKING FLUID

Masking fluid can be very useful for certain shapes and for small areas such as stamens and various textures. You can apply it with a brush or pen – allow it to dry before painting over. It enables you to work quickly over difficult small details, but beware of its disadvantages. 1 Always clean the tool you use immediately afterwards. 2 Remove the masking fluid as soon as possible; if you don't, you will find it takes up the paper and your painting will be a disaster. It is possible to use wax crayon to resist the paint and also to scratch out certain detail. For this you will need a sharp scalpel and great care. It is also possible to use masking tape which can be cut to shapes which resist the paint; blotting-paper can also be used to remove paint areas.

Many artists leave a fine white line between areas of paint because they have applied the paint quickly. If a wash is wet and you wish to paint up to it and not let it run, leave a hair-line space, which will add to the sparkle and liveliness of a painting. An occasional bleed-in can, however, look spontaneous and deliberate.

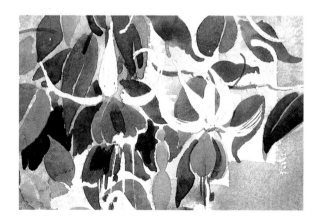

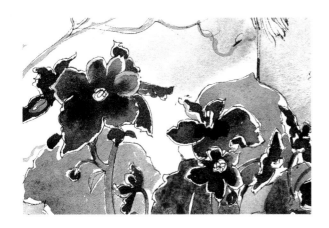

LINE AND WASH

An alternative way of portraying flowers is to use pen and wash. It is basically a drawing technique with the colour lightly washed in afterwards. Alternatively, you can put colour down first and delineate your flowers by drawing with ink. Care must be taken to decide which ink to use – Indian ink is waterproof and will not bleed or run. If you are using a felt-tipped pen, make sure you know whether it is waterproof or not.

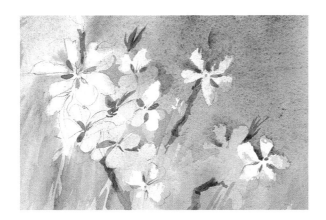

BLOTTING-PAPER

Blotting-paper has many uses. The obvious ones are well known, but it is invaluable for taking out small areas. It can be creased or folded, or cut to certain shapes and pressed on damp paint, where it can be used to lift paint to make lighter shapes. The sponge can be used to create certain effects – for example, distant trees – but moderation is important. A toothbrush is fine for the casual spattering of paint, in judicious areas.

TEXTURE

Many different materials can be used to make marks on paper – textured fabric, cork, leaves, etc – the list is endless. Using this basic printing process, intriguing effects can be produced or certain textures can be portrayed. Use a sponge to imitate the leafiness of a tree or a toothbrush to spray a random dotted texture to resemble earth or pollen. Other items can be used as tools – use your initiative and imagination. Drag a comb over thick paint and appreciate the result. Different textures, if used wisely, can liven up a painting – sometimes these effects occur by accident and at other times they can be quite deliberate. A piece of card can make short staccato marks if it is used on end as a printing surface.

LIGHTING

Sunlight illuminates in every way. Low sunlight casts mysterious long shadows. Sunny summer afternoons in the garden can be the best lighting of all. The light creates the form and makes patterns of light and dark which intensify the colour values. Painting shadows on flowers can be difficult – the shadows are not only a darker version of the colour but they contain reflected colour and can be very beautiful. If you want to create a strong light which impersonates sunlight you must use a spotlight.

Strong lighting accentuates the tonal values and increases the brilliance of colour. Soft lighting will create a high-key painting. Lighting affects the mood of the painting – bright, cheerful and light colours, or darker, more saturated colour. Watercolour usually suggests pale, light colours, but it can be used to create strong dramatic work if your contrasts are heavy enough.

Many artists love back-lighting, which creates a strong tonal shape which is defined by a halo of light. Light can create pattern and accentuate texture, but experiment with your light source before you are satisfied with it.

Natural light is something we take for granted,

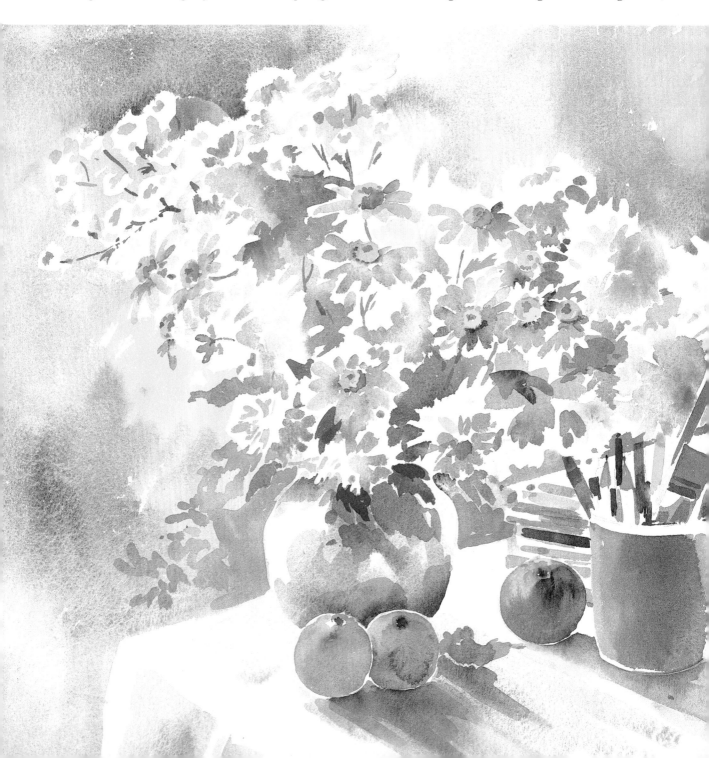

but everybody is aware of the atmospheric effects which are created by changing weather. One of the most startling effects that occurs near my home is caused by the contrast of sunlit willows against very thundery skies – the contrast of the ochre-coloured trees against indigo is breathtaking and is occasionally highlighted by white gulls. The changing effects of weather are not easy to achieve in paint – no sooner are you set up than your subject changes. Your sketch-book can be useful at such times, when colour sketches of changing effects can be taken. For speed, a small box of pastels with a limited colour range can help you to work directly.

STYLE

The *Oxford Dictionary* gives as one definition of style 'the manner in which a work of art is executed'. Style is often easy to see in another artist's work, but not in one's own. You can admire the work of artists whose styles may be completely different. It is often the individuality of an artist's work that gives it style. You may be passionate about broad, flowing work and incorporate this style into your own work, or you may like the realist's approach, of detailed description.

There are many contemporary artists whose work is delightful and completely individual. Most districts have galleries which show a variety of paintings, and there are also regional and national showings of paintings. Art magazines are one of the best sources of information about exhibitions.

It is interesting to look at artists' work. Some produce paintings that are loose and free, while other artists' work can be precise and detailed; creativity depends on technique and temperament. As you continue to paint a style may emerge unconsciously. Many students develop a style which imitates an artist's work whom they admire. One can see many examples of paintings whose style has been copied, sometimes extremely badly. An artist must work hard and honestly, and must decide what goals to work toward; an individual style will follow. Your aims can be very simple – for example, improving your drawing technique.

The medium an artist uses can affect style to a great extent; the subject matter often is a major influence on this choice. An artist's likes and dislikes will affect his way of working – for example, a preference for light or delicate colour will create an entirely different painting from an artist's whose palette is darker.

Your painting may be descriptive or decorative, or it may have a specific function (earlier flower paintings were definitely of a botanical nature). You could accentuate the colour values or the composition. Often flowers are included in a painting to enhance certain colour values and to provide a contrast to more sombre tones. Colour can affect the mood of a painting. It is worthwhile to note the style of certain artists and to analyse why their paintings are successful and why you admire them. Some names to look for are John Sargent, Charles Rennie Mackintosh, Russell Flint, Edward Seago, and, of course, William Turner.

INSPIRATION

*Two direct sketch-book paintings, with rapid
observational sketches of trees, flowers and light.
These were painted directly with the brush,
attempting to achieve correct tonal contrasts – that
is, light to dark and vice versa. There was no
preliminary drawing with a pencil. The lightest
colours were put down first with a general progression
to the darker tones. Spontaneous sketches such as
these often clarify subjects which otherwise can seem
too complicated*

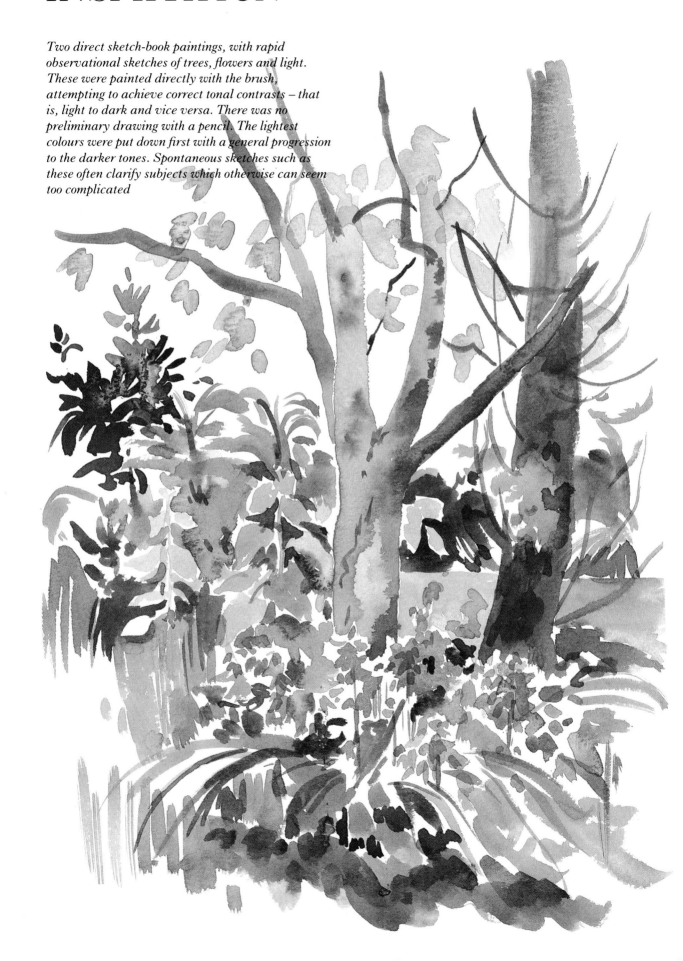

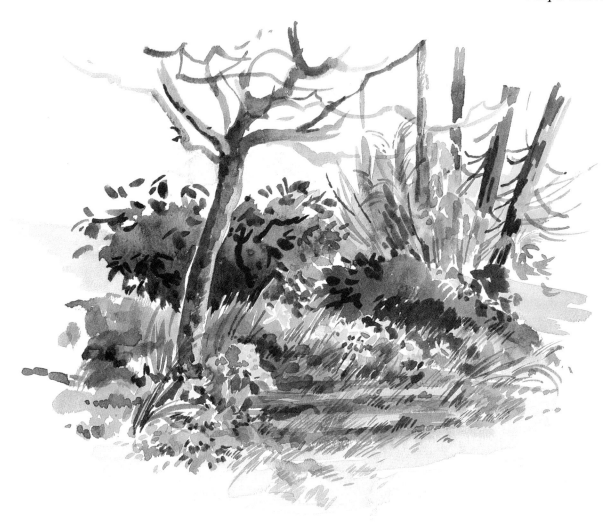

Finding the right kind of inspiration to start painting is not always easy. Obviously, if you see a beautiful array of sweet peas in June, you don't need to look much further, but at other times inspiration is harder to find. Sometimes a flower shop is the answer, but often if you look at the plants you have at home you will find that these, combined with coloured materials or decorated china, can provide your subject. There may be some specific point you wish to make about colour or light, but if your experiment doesn't quite work, you can always try another time. Unusual colour combinations and techniques that intrigue you can be experimented with. Most artists are constantly experimenting and evolving ideas. Each fresh subject is new to the artist and will present problems and difficulties to the more experienced artist as well as to the beginner, who often has technical problems to deal with as well.

Painting directly from your source of inspiration can take several forms. You might be intrigued by light falling through trees on to daffodils or bluebells, or the chance arrangement of an imagined group of flowers and your favourite pottery and lace tablecloth may be just what you need. To have your paints ready and your paper stretched and waiting for those first wet spreads of colour is one of the most exciting feelings I know. The paint itself can suggest arrangements and often the imagination can supply the rest.

The more simple the subject, the better. Don't be too ambitious to start with as often on completion of your painting you will realise that a small part of your composition would not only be easier, but more attractive. Even when you are pressed for time, it is still good practice to try your thumb-nail sketches and to ask yourself questions about your arrangement or subject. For example: 'What is it that attracts me to this particular subject?', 'Am I taking in too much?', 'Is it crowded and busy?', 'What am I trying to convey?' It is all too easy to get side-tracked into producing fussy compositions.

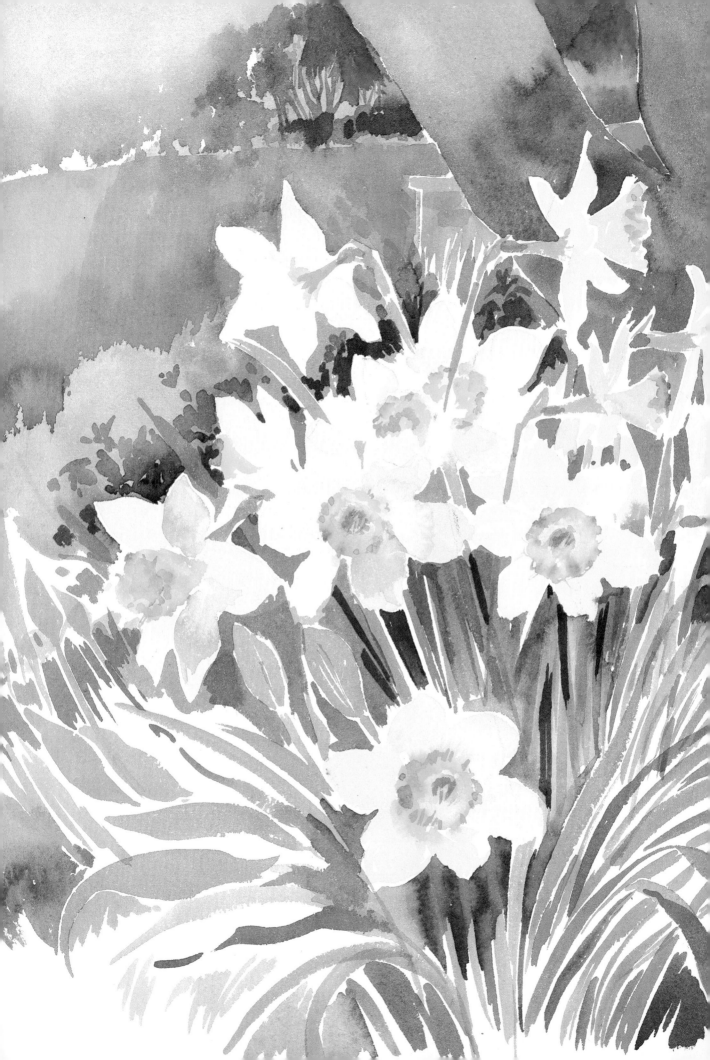

Spring

In spring the weather can be full of surprises; one day the sun shines and the world looks marvellous, while the next it can be cold, windy and wet. The temperature rises slowly and each warm day encourages new growth; plants you had forgotten about seem suddenly to appear and in my garden the amount of flowers actually blooming is quite surprising.

At last, after weeks of waiting, it seems as if spring has arrived. First the crocus appear, and then one glorious day when the sun shines all day the daffodils come out. Suddenly you start to notice that there are all sorts of plants about to burst into leaf or bloom. The prunus and the almond trees fill the streets with delight. The colours of spring seem to be mainly yellow and mauve – the perfect complementaries.

The lightness and brightness of spring colours after dull winter days are delightful: all the yellows from pale lemon to the sharpness of gamboge; delicate leaf greens made with raw sienna and hooker's green; the mauves and purples of crocus, primula and iris; and the blue-purple of grape-hyacinths. How lovely they are – you can almost think of the seasons according to the colours of flowers.

The brightness of daffodils seduces you into thinking of cadmium yellow pale and aureolin. Their very delicacy is a siren call to painting and it is easy to get lured on to the rocks. What makes a daffodil bright? Apart from the colour, it is the very transparency and lightness of the petals, and to be able to achieve this you must be aware of your background.

The breathtaking beauty of almond blossom can also keep the artist busy. Do you paint the whole tree or just parts? As you look up through the tree to the sky, the contrast of pink and blue is startling, and on a rainy day is even better. Spring is such a busy time for gardeners that painting can even take second place. After all, you have to grow many of the plants you want to paint!

TONAL VALUES

One way to achieve successful painting is to get your tonal values right. If a painting reads well – that is, it is not confused or jumbled up – it is because the tonal values are correct. By tone I do not mean colour; an article which is dark blue, for instance, can, when light is shining on it, appear quite a different shade.

It is useful to think of tone in a range of greys from black right down to white. Look at your sub- ject – decide where the darkest parts are and note where the lightest area is. Other tones will fall between these. Think of your design as a pattern and fit one tone to another regardless of colour. In some areas of a painting this is easy, in others it is difficult, particularly where the tones are similar. It is a matter of judgement as to where emphasis can be put, but generally there could be a passage in any painting where the darkest tone comes up to the lightest and this is where the eye will be drawn. In some cases you may have to falsify your tonal values in order to achieve more contrast, and add more vitality to a painting.

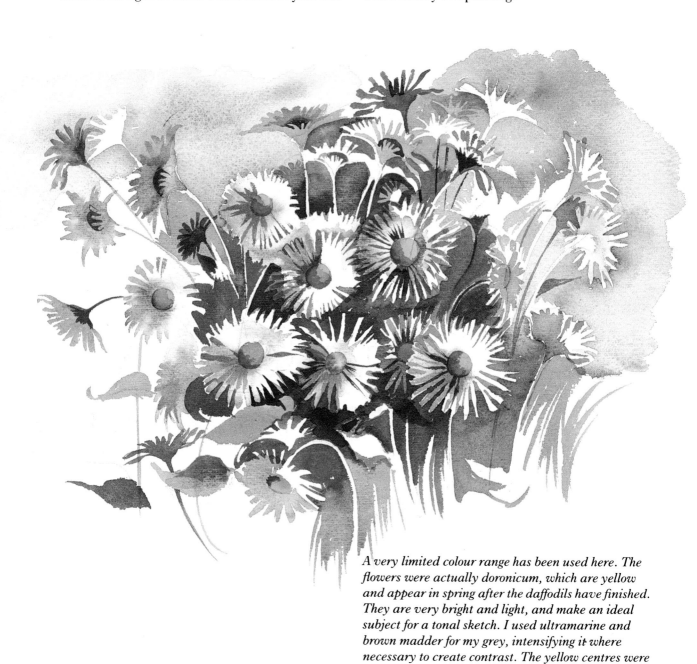

A very limited colour range has been used here. The flowers were actually doronicum, which are yellow and appear in spring after the daffodils have finished. They are very bright and light, and make an ideal subject for a tonal sketch. I used ultramarine and brown madder for my grey, intensifying it where necessary to create contrast. The yellow centres were an afterthought

38

PAINTING WHITE FLOWERS

White flowers are seldom white; they can be slightly pink or green and almost certainly some of their petals will be in shadow. Nature never produces white flowers in a void. We always see them highlighted against the sky or other flowers, or against leaves, etc, so in some cases you will have to cheat a little and provide some sort of background for your pale flowers. Light mostly comes from one source, so it should be fairly easy to see a dark and a light side to your white flower.

We have already discussed leaving white shapes, and the use of masking fluid when painting smaller white flowers, stamens and small shapes which are difficult to paint around and often forgotten when applying a wash. It is possible to use masking fluid on a tinted ground, or one can tint the areas left afterwards. White gouache is a useful addition to your equipment, but for painting white it does not have the brilliance that the white paper does. It is useful for adding to watercolour occasionally when you feel that an area needs extra light shapes for contrast – for example, light leaves on trees. Some artists prefer to use gouache, which is, after all, a water-based paint. Gouache is opaque watercolour and has a paint layer unlike watercolour, which is a stain and depends on a white ground for brilliancy.

Chinese white is a zinc white which was first introduced in the 1830s for use as watercolour. It was widely used in Victorian times, but has lost its popularity, probably because of a change of style.

When using watercolour, the edges of white flowers can be defined by the area surrounding them, whether it is leaves or other flowers, or areas of washes; the shape is therefore held by the background. Some painting can be left to the imagination, but this depends on the flowers painted. Frothy white blossom is better depicted as a mass rather than as individual flowers, and the tonal values of the flowers would then come into play.

PAINTING LEAVES

When horse-chestnut buds burst they are fascinating, and it is surprising how such large leaves can have such small beginnings. The leaves uncurl and grow daily like small fingers

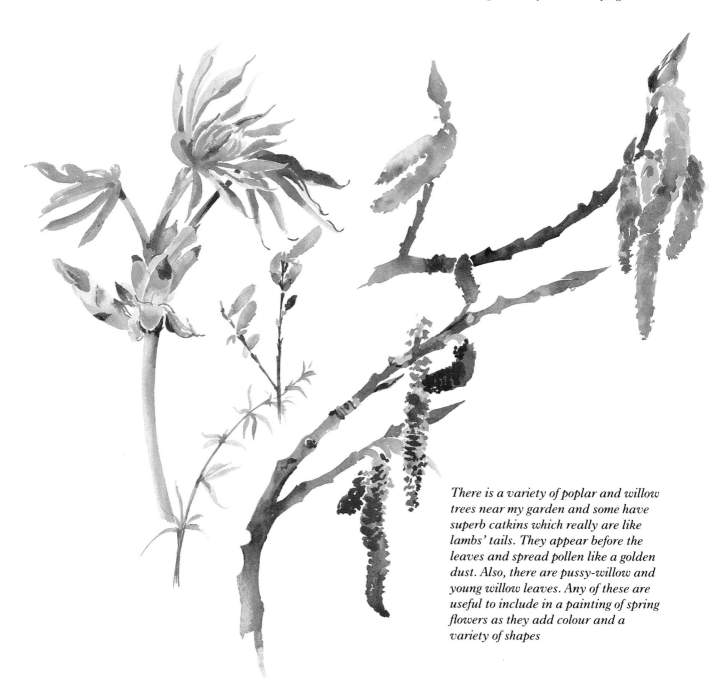

There is a variety of poplar and willow trees near my garden and some have superb catkins which really are like lambs' tails. They appear before the leaves and spread pollen like a golden dust. Also, there are pussy-willow and young willow leaves. Any of these are useful to include in a painting of spring flowers as they add colour and a variety of shapes

There are many different leaf shapes. Some like the new horse-chestnut leaves illustrated are like hands with fingers – delicate pale green fronds not at all like the fully grown leaf. Notice that the line is taut and sharp, not drooping or wilting. Learn to draw directly with the brush – one or two pencil lines will give you confidence.

In painting leaves with definite veining, use folded blotting-paper which will lift out the light veins, or the colour may be lifted with a wet brush and blotted dry. Find the technique to suit the leaf. The right brush can help a great deal. The rigger can make the fine lines necessary to paint ferns perhaps, or your largest wash brush can success-

fully put down the large leaves in one stroke. Note if your leaves are tinged with red or ochre.

The direct use of certain brushes can represent some leaves. A steady hand is the best answer to painting daffodil leaves and other long shapes; if your hand is less than steady, try to use as few strokes as possible – use a loaded brush and drag the colour out. Some artists steady one hand in the other, but a flexible wrist is the best answer. Put other brushes to use in delineating all kinds of leaves, and never use two strokes where one will do. Obviously, if your leaf contains various colours, shading from brown to green or yellow, a different method will need to be employed, and here a wet-into-wet technique will be useful. As leaves can be all shapes and sizes, so can their colour. Green can be obtained from many mixes: blue and yellow, of course, but yellow and black also make green. I work on a simple principle of light, medium and dark greens and work out variations of mixes.

As can be seen from this page of different leaf shapes, there is a tremendous variety of sizes and shapes. It is certainly not always necessary to put too much finish into leaves. It is the character which is important and what kind of habit the leaves have. Get into the habit of noticing different shapes, whether they are soft or spiky, smooth or rough, or if the leaves grow up or down. Dark leaves can make a marvellous foil for pale flowers and we should learn how to exploit the colour and shape of foliage. In these illustrations there are different kinds of leaves for which I used a No 8 sable and a No 3 sable, using the brush to make the shape in as few strokes as possible. In some of the leaves there is overpainting, in others there is the merest change of colour. Note also the colour of the stem – often it can be brown or red in contrast to the green. The leaves illustrated here were painted direct, with no pencil drawing. Had they been completed, they would have made pleasant paintings on their own.

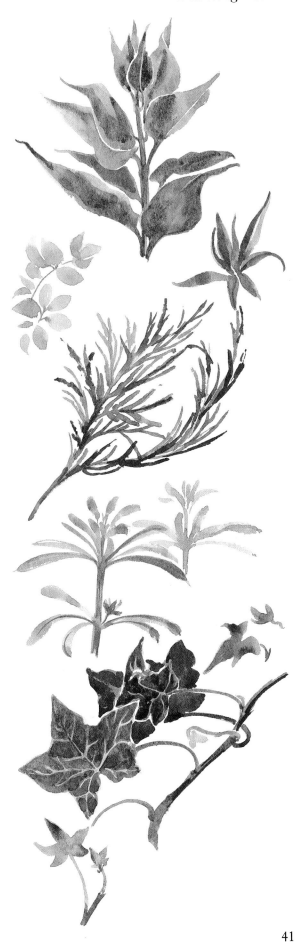

WET INTO WET

Many of the paintings in this book contain examples of painting wet into wet. It is a technique which involves painting on damp paper and letting colours run into one another and blend. It is used in conjunction with other techniques. It is fascinating to do, but many people get carried away and make a runny mess. It is useful for backgrounds and cer- tain soft effects, but to my mind it should be unobtrusive and part of the painting as a whole.

The wet-into-wet method works well when you have light coloured flowers which can be sil- houetted (in reverse) against a darker background. There are various ways of using the wet-into-wet method, and you certainly need to practise it. One way is to work on stretched paper which is damp, painting your flowers in and increasing the colour as it dries. The edges will diffuse and run, but these can be tidied up later. Any sharp or crisp detail can be added when the painting is dry. Another method is to damp the shape of the flower only and then to place your colour in the centre. The damp paper will allow your paint to spread, but will be confined by the shape; this is an excellent way to

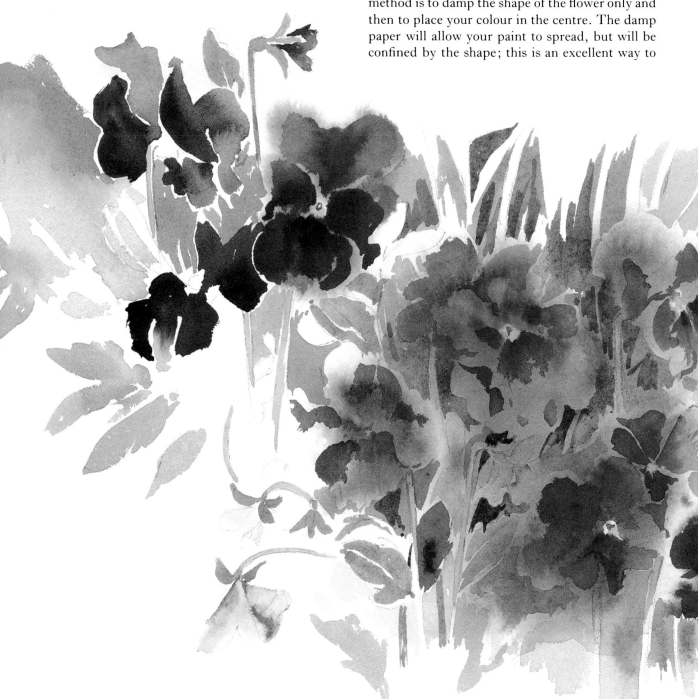

achieve the delicacy of flower tints. Maybe your painting will need just a veil of colour for a suggested background and the wet-into-wet method is perfect for this. Don't forget that to make your paint run, you may need to tilt and tip your painting surface. Your overall original background will help to create a unity in your painting.

You must remember to mask out any white flowers, using a masking fluid or blotting out the shapes initially. This is an exciting technique and one that requires an open mind regarding the results; often it is sufficient to have some crisp detail and to let the background remain blurred and out-of-focus. The results can be similar to photographic close-ups, where the lens can pick up in detail either the foreground or the distant view. The human eye is more sophisticated and allows us to see a great deal of detail at several distances; as an artist this is difficult to portray unless you are a super realist. The brain can often fill in for the eye

and suggest forms where there are none. Many students find this way of working difficult, as the element of surprise is unnerving. You have to be able to improvise and to be prepared to abandon paintings if they don't work out. Using a wet-into-wet technique for individual flowers is not difficult – as a technique it is supremely efficient to portray flowers which often combine different tints. It is a question of judging how much paint and how much water you need, and with practice it should be second nature to make this judgement.

PANSIES

These pansies were painted in front of the subject, with some idea of the composition in mind before starting. The blue of the pansies was quite intense and the flowers were massed. The paper was dampened with a sponge and colour was dropped in where the flowers were wanted. The colour was pure, not mixed. However, when overpainting, some of the colour was mixed. I then started to work into the actual flower shapes, adding washes where necessary. It is also possible to subtract, if needed, using blotting-paper. The painting is deliberately left unfinished to show how the wet colour looked. This is just one way of working with damp paper; mostly it can be used where a feeling of vagueness is required.

This painting shows the blurring of outline and the soft veil of colour. The second tone was painted when the first was practically dry. The flower shape was delineated by the background green of the leaves, the green also being used in a fairly loose and wet way. In the case of the blue pansies, the depth of colour made the green background rather dark, but this can be used as a contrast to lighter and brighter tones elsewhere. The edge of the initial wash can be seen quite clearly. The technique is fascinating – it is soft and kind for flowers and in the case of pansies works particularly well.

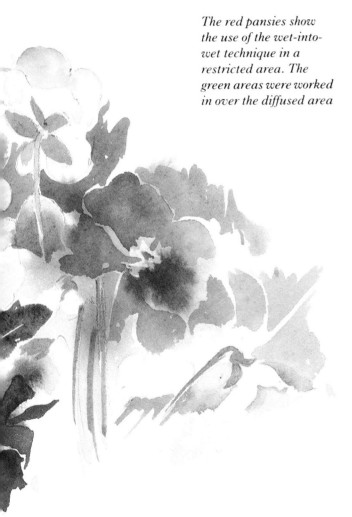

The red pansies show the use of the wet-into-wet technique in a restricted area. The green areas were worked in over the diffused area

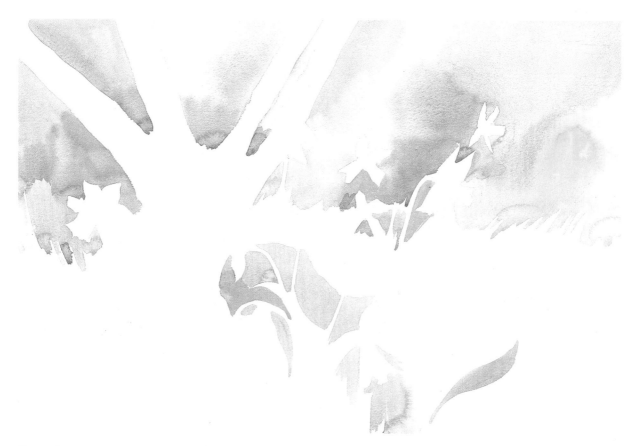

Stage 1

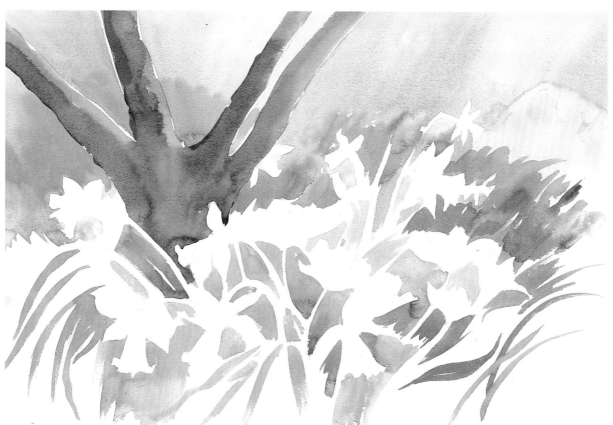

Stage 2

44

RED TULIPS

Materials: 140lb Arches Not (unstretched); normal palette plus winsor red, cadmium yellow pale, cadmium orange, and cobalt blue; No 8 and No 3 sable, ¾in wash brush.

Stage 1

The general position of the tree and flowers were lightly indicated in pencil. The sky was brushed in using cobalt. Hazy bushes were indicated in wet-into-wet using prussian blue, raw umber and a little hooker's green. Make sure you mix enough cobalt and, using your largest brush, quickly paint in the sky, leaving the white shapes as indicated. Don't worry if you go over some edges.

Stage 2

I continued with the same green as for the bushes, filling in spaces between the flowers. When the sky was dry I put in the tree, using prussian blue and brown madder with a drop or two of hooker's green, letting the colour diffuse and run. For the spaces between the flowers and leaves I added ultramarine and cadmium yellow to create a variety of green.

Stage 3

The flowers were painted next using winsor red for the tulips plus a touch of cadmium orange. Cadmium yellow pale was used for the tulips. More leaves were added and the blue area on the right was strengthened. I also added some pencil work to define various areas.

Stage 4

This latter stage was where various alterations were made. The tree received more work, as did the leaves, stalks and background. Dark areas were increased and branches added. The feeling of a blowy spring day was difficult to achieve. The larger sable was used as the painting was quite large, and I wanted to create a fresh, immediate feel. It is a good idea to put your painting in a place where you can see it every day. Often, fresh ideas about composition, tonal values and execution will enable you to have constructive thoughts about its completion. It is sometimes difficult to know when one has finished a painting, and easy to go on fiddling and touching up. The latter stage was much the longest and a good deal of adjustment was made.

Stage 3

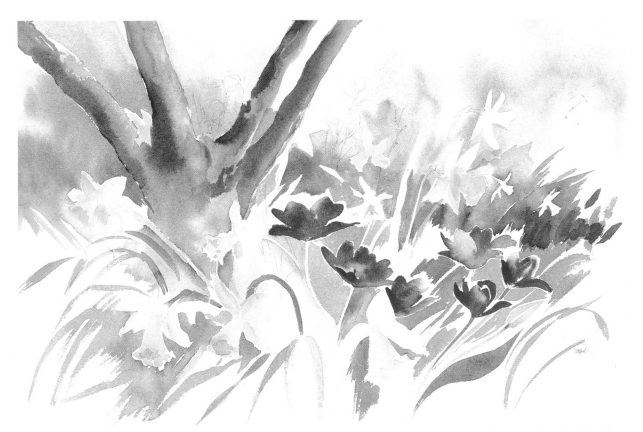

Stage 4 (overleaf) ▷

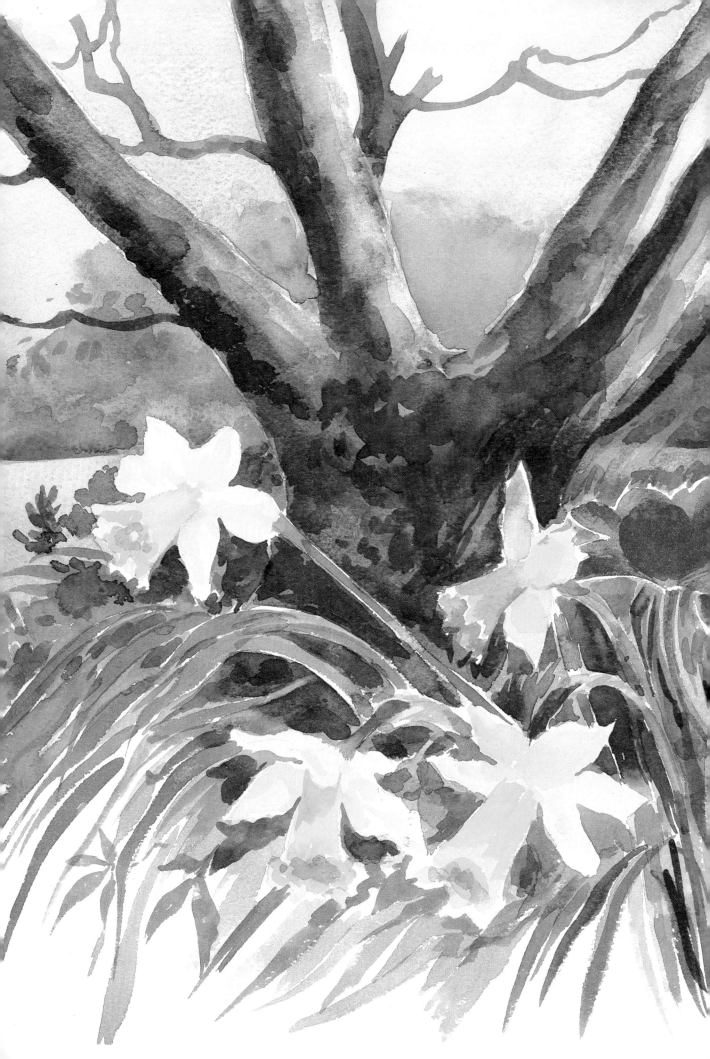

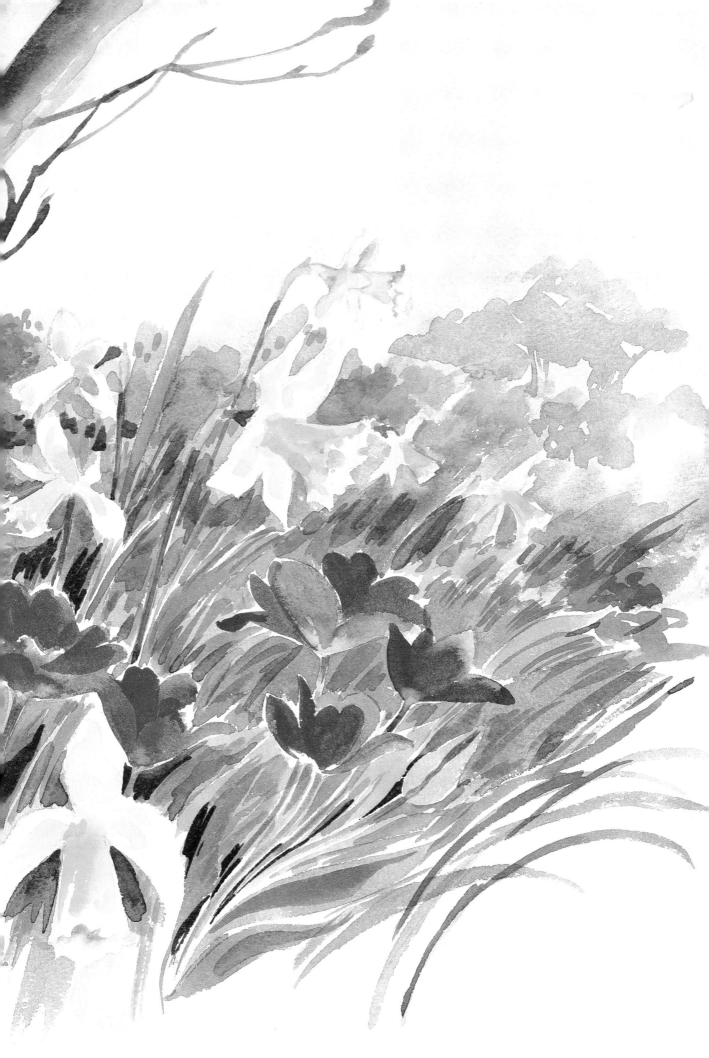

PAINTING VEGETABLES

The most unlikely plants make good subjects for watercolourists. Those who are just starting to learn to paint can practise using vegetables, either singly or in more complicated groupings. With beginners, one of my first lessons is to teach students to paint onions, which are available at any time of the year. They are simple, natural shapes to draw and often have lovely little roots. This lesson is the first in mixing colour and trying to match it to the subject. To progress from painting one or two onions, try putting several in a paper bag (which provides a background), then add other vegetables: swedes with their lovely purples and pinks, baby turnips which are such delicate creamy colours, celery, mushrooms – the list is endless. The combination of earthy colours can be delightful.

As subjects, vegetables are available all the year round and can be found in everybody's kitchen. As you grow more confident as an artist, you can add a basket or boots to make your still life more interesting and difficult. When painting onions, it is a good idea constantly to compare your product with the real thing. Hold your painting up to your subject and see if the colours match, not forgetting that watercolour will dry much lighter than you thought possible. It is always advisable to mix your colour a little darker to compensate for drying.

Cabbages are useful in learning how to mix green. They are like lovely green roses. Start with your lightest green and finish with the darkest, not forgetting to adjust the warm or cool element in the colour. Use the veins to practise the various techniques we have discussed (refer to the section on colour for green mixes).

SPRING ONIONS

48

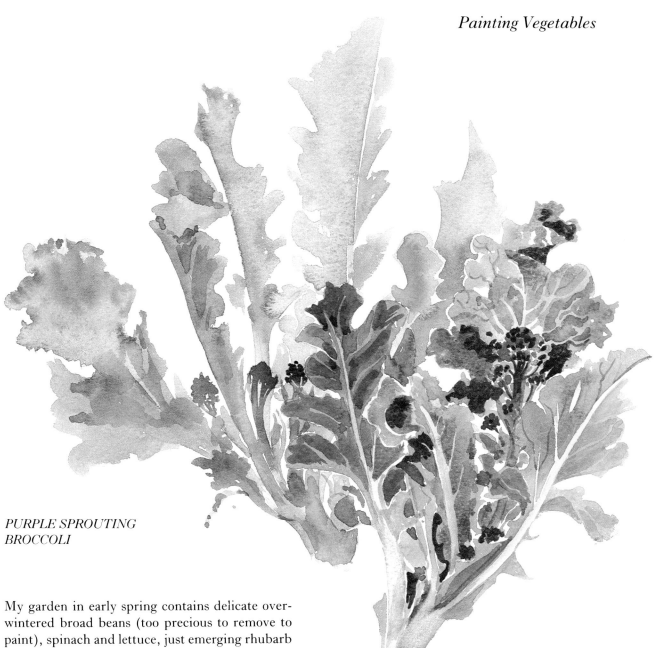

PURPLE SPROUTING
BROCCOLI

My garden in early spring contains delicate over-wintered broad beans (too precious to remove to paint), spinach and lettuce, just emerging rhubarb and purple sprouting broccoli. What better subjects could you have when practising using green? Vegetables always seem more down-to-earth than flowers; they are straightforward, no-nonsense plants.

SPRING ONIONS

These delicate spiky leaves and tiny bulbs were difficult to see as a whole. In fact, although it looks a simple painting, it was very intricate and difficult to produce. A lot of patience was required to interlace the leaves, but it presented a challenge. The fibrous roots were painted in gouache. This particular subject confirmed my thoughts on painting small shapes – you need to specialise in painting miniatures. Large simple shapes are much easier and lead to a greater freedom with the brush.

PURPLE SPROUTING BROCCOLI

Using the same palette as the previous studies, the little purple sprouts were painted first followed by the leaves. As it was such a large plant and rather a cold day, it had to be painted indoors, which doesn't do justice to such a prolific vegetable, so this is just a small part. It has similar features to rhubarb but is smaller, with intricate curling on the leaves, which is quite difficult to draw. The leaves in the background were not purple/grey, but I felt they should recede into the background, so I cheated on the colour. This effect can be used with other plants, and sometimes just a pencil drawing can create distance when used in conjunction with a painting.

49

LETTUCE AND CHIVES

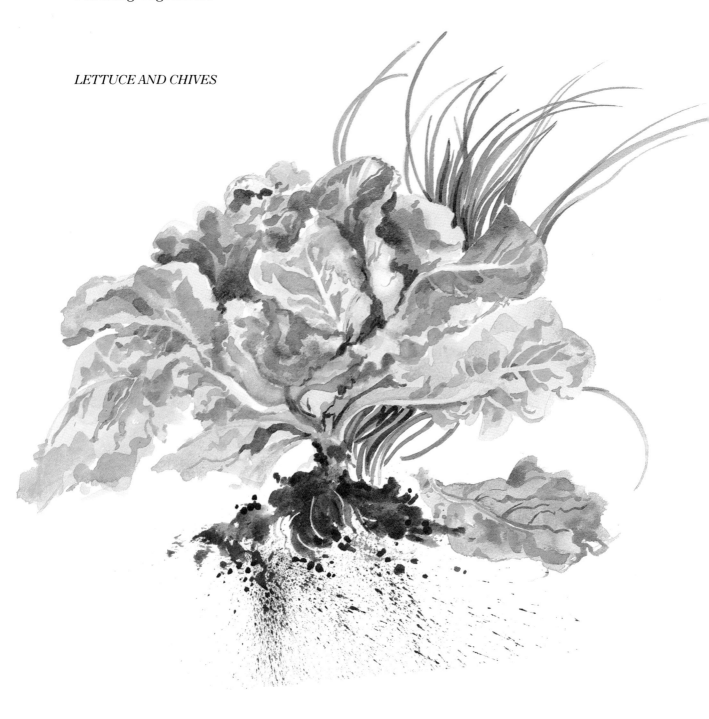

PAINTING LETTUCE AND CHIVES

Predominantly, the colours used were winsor yellow, yellow ochre, raw umber and hooker's green – part of my normal palette – which were painted on 140lb Bockingford.

The lettuce was picked and painted immediately while it was very fresh. I wanted to include the root as it provided a contrast to the delicate greens. Using a pale green the main shapes and outline were drawn in with a brush, followed by progres-

sively darker greens. The darkest tones had been noted and tentatively placed. As lettuce is a particularly 'green' vegetable, it was important to differentiate the tonal values. It is enjoyable working on white paper as you don't have to consider backgrounds, but you do have to think hard about values. The chives were added at the last moment, as was the spatter work on the root. As well as contrast of tone, a subject can be livened up by contrast of texture and line.

RHUBARB

This subject provides lovely strong shapes and curves. It has a strong colour and delicate tints, with perfect complementary colours. The veining on the leaves was very distinct and positive. A light wash was laid first, followed by a medium and then a darker green. The red was a combination of winsor red and brown madder. The veining creates pattern and this became an interesting facet of these vegetable paintings. All of these paintings were produced during the first week of April after lovely sunshine and then heavy rain. You could almost see the rhubarb grow! It is a particularly vigorous variety which never fails to give a good crop. Towards the end of the season the leaves could have been used as umbrellas as they were so large.

The lessons learnt from painting the rhubarb, etc on this page were useful; I had to work very fast as the subject wilted quickly – there was no time for delicate pencil drawings. I learned a tremendous amount about green and making various mixtures. It was helpful to work over the whole area and although these were apparently simple paintings, a great deal of thought went into making an interesting portrayal.

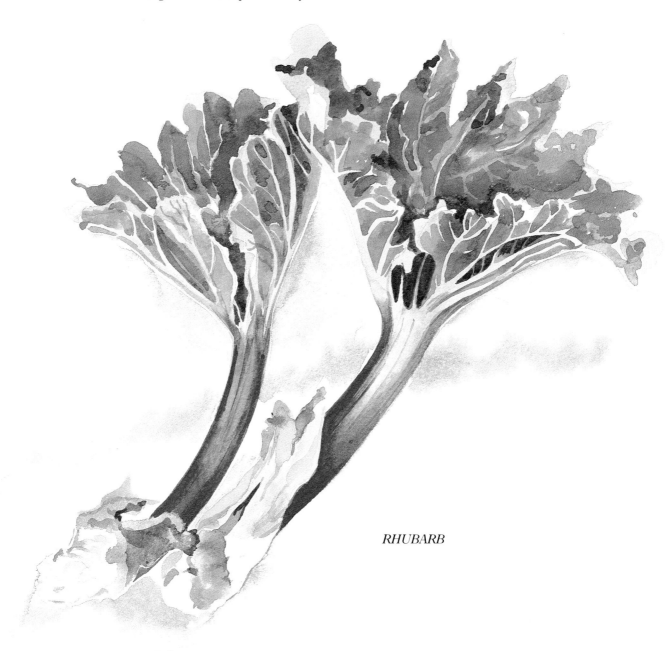

RHUBARB

BEARDED IRIS

The bearded irises which grow in my garden are tall and striking and a heavenly light blue-purple-mauve. The tissue-thin petals are large and there is an almost calligraphic detail in the centres. They are extraordinarily lovely. The shapes are large and

Rough colour sketches are a good way of working out your ideas on tone, colour and composition

(Opposite) The first stage is enquiry. What kind of brush strokes will you use? Which brush? Which blue? Is it a warm blue? How do you make the darker tones in the petals? Your studies should give you the answers

simple, and the sword-like leaves complement the flowers. Sometimes you have to judge the right moment to paint – if you wait a few days their beauty can fade. In late spring it is often possible to paint outside, but if this is impossible, pick one bloom and make studies until you can work outside.

If you feel nervous about painting immediately, you could draw with a pencil, but it is best to get into the habit of using a brush straightaway, transferring the shape you see on to the paper directly. There are many different ways of approaching your subject, but you could try out various small-size rough ideas in colour (3 × 4in (76 × 102mm)) and, as you work, your ideas about your painting should crystallise. I find that, having been thinking about the subject for some time beforehand, I am very enthusiastic once I start. As I love to paint in the garden, I try to let my subject be my guide. I may have to adjust certain things as I go along, but I always refer to the subject in front of me. I consciously try to balance one shape against another, and a dark area against a light one.

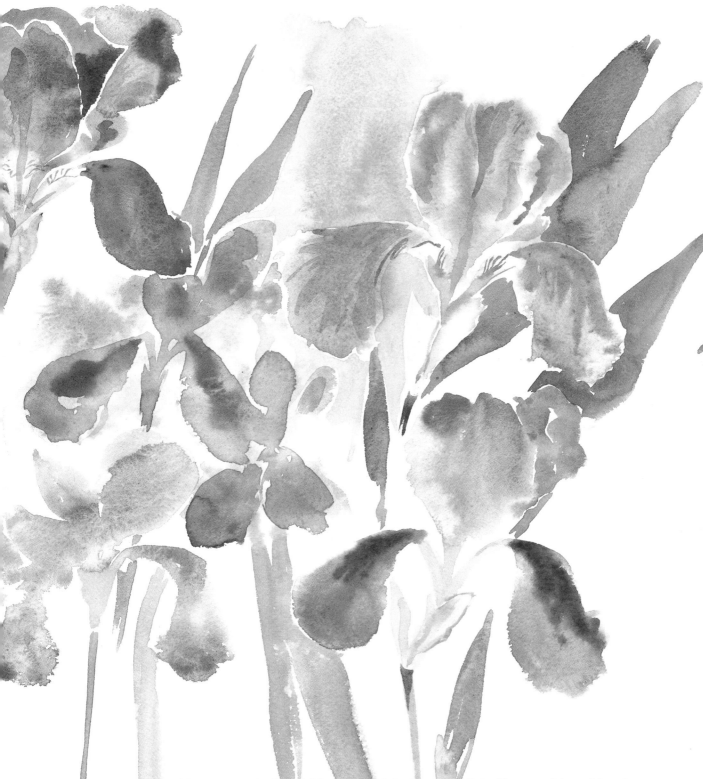

(Overleaf) Working outside on a stretched 140lb Not paper, I dampened with a sponge the whole of the paper and laid in a suffused wash of diluted cobalt blue, letting it drift down the paper, using my hake or mop brush. While the paper was still damp, I indicated the positions of the various iris. If the paper isn't too wet, you can draw into the flower shapes with darker tones, creating a soft petal-like effect. This rush of creativity has to be followed by a careful consideration of stems, buds and leaves – a kind of mapping out process. You have to work fast, not only to capture the beauty of the flowers which fades all too quickly, but also to achieve the free feeling of the medium. Your advanced planning should enable you to find the right colours, the right greens, but adjustments can always be made

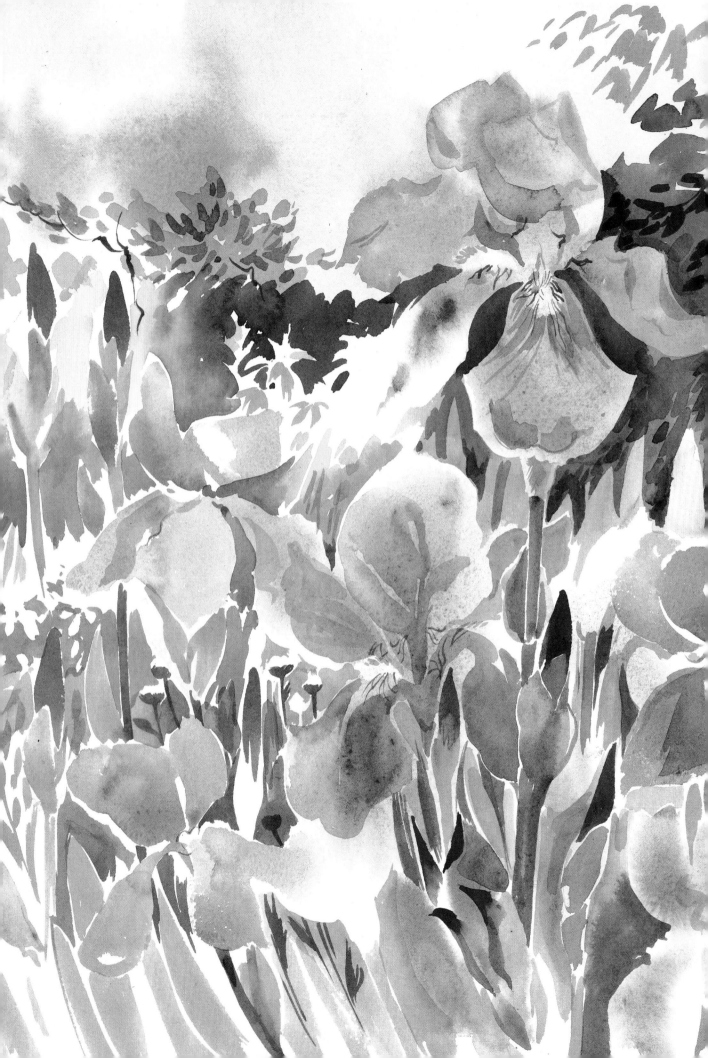

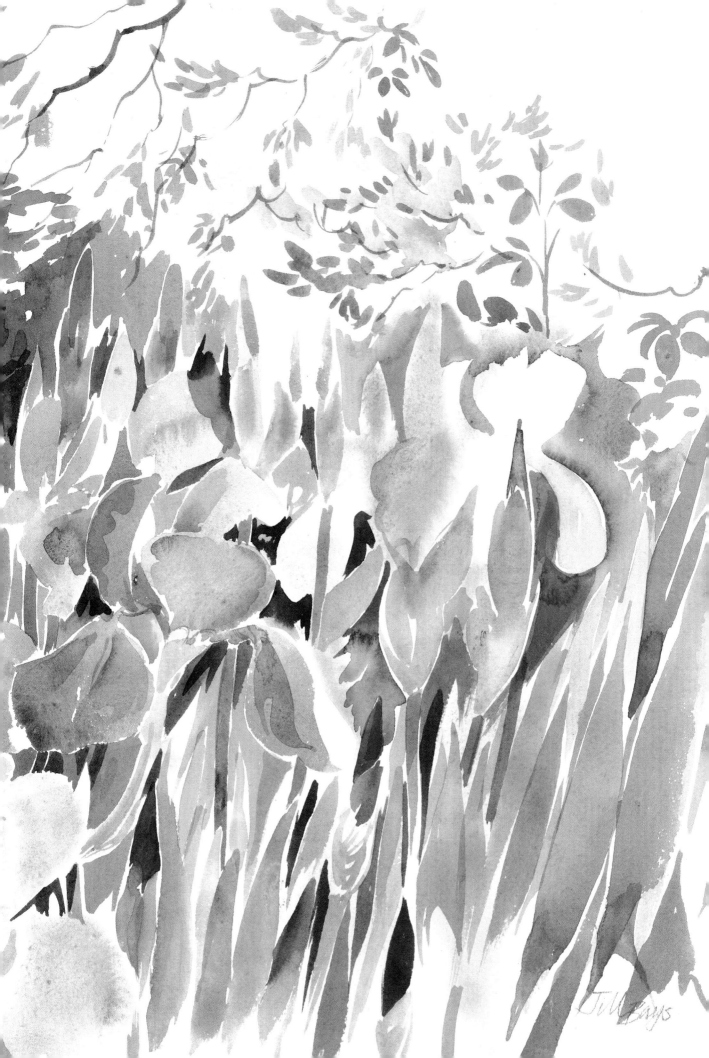

DRAWING ANEMONES

Some artists love to draw for its own sake and are reluctant to give it up. Of course, painting is drawing, as it combines both skills. If you are tentative about painting on its own, there are ways in which you can overcome this. You can draw in whatever medium you prefer and then use a light colour wash. Your drawing can supply any tonal value and your colour can be local colour (that is, the actual colour of the subject). Some people prefer to put down washes first and then to draw on top; there is no right or wrong way, you just find which way suits you. Starting this way, you gain confidence and ultimately find that you can dispense with the line work.

On the subject of drawing, different coloured pencils are available which combine well with watercolour, giving extra detail if needed. There are many different media which you can use for drawing, but you may become a jack-of-all-trades and master of none.

The first drawing below was made with a 2B carbon pencil, which creates a lovely soft yet black line. The pencil can be sharpened to a point, but is liable to smudge slightly.

The middle drawing is in ink drawn with a brush

(No 4 sable). A disadvantage is that you cannot rub out a mistake. Behind the brush drawing is a pen drawing made with a fine steel nib and Indian ink. The drawings were made on cartridge paper, which is smooth. Hot Pressed paper which is hard and smooth would be ideal for these kinds of drawings.

The lower drawing was made using a B pencil, which produces a much greyer drawing, but you can put in very fine detail as well as tone. An advantage is that you can use an eraser if necessary. Always draw with a well-sharpened pencil, having as long a point as possible; it can be sharpened on a piece of sandpaper if necessary.

I bought a small bunch of anemones on a cold spring day and decided to paint them as studies on white paper. I watched them slowly open in the warmth of my studio. I started with one bloom and gradually added more. There is hardly any overlapping, making this an easy exercise for a beginner. As there were very few flowers I painted them from all angles, turning and changing their posi-

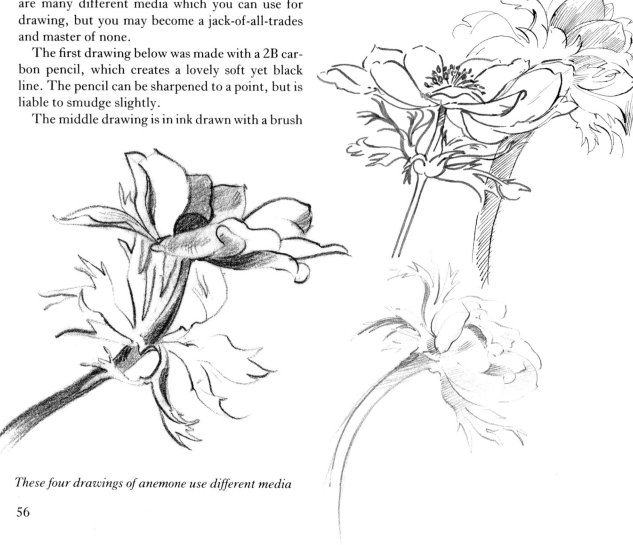

These four drawings of anemone use different media

56

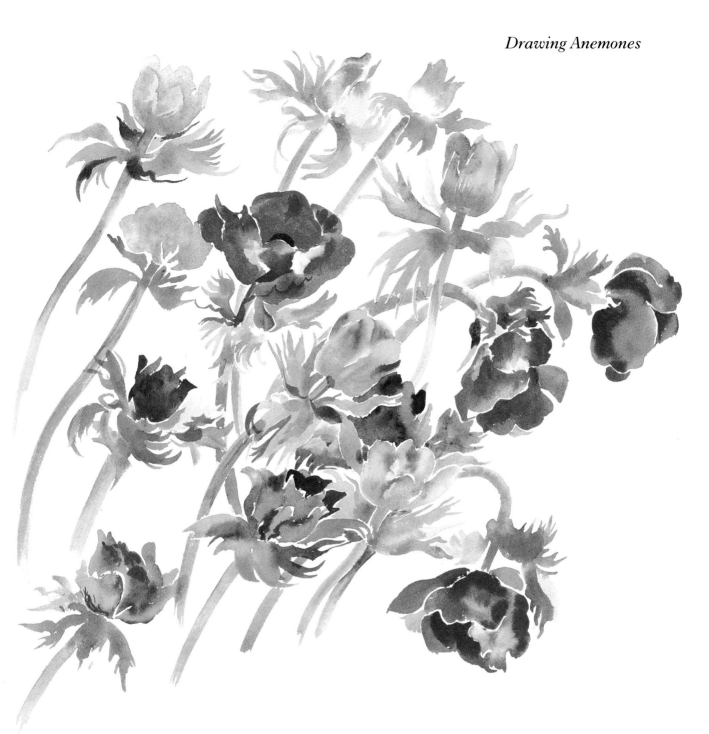

tion. They formed a pattern on the paper and it was challenging to interweave them as the colours were so rich and clear. Some of the flowers were painted directly in with a brush, others were lightly drawn with a pencil. This was a useful exercise for drawing with a brush and for practising small areas of wet into wet on dry paper. I used 140lb Arches Rough paper and No 8 and No 3 sable brushes. Added to my normal palette were rose madder genuine, magenta and mauve.

When painting on a white ground (white paper), you eliminate all kinds of difficulties. You can concentrate on the subject wonderfully. In this case, the anemones were used as a vehicle for practising the wet-into-wet method using my brush, and also for getting familiar with the various reds that I encountered. In the warmth of a room, you can almost watch the petals uncurl from their pinched buds into the richest of colours and shapes. I noticed from the resulting painting that fine white dividing lines were left; this was due to the speed of working and not letting one wash run into the next while it was still wet. Although apparently stylistic, it was as much necessity as anything else. Many flowers lend themselves to this kind of treatment; they are semi-botanical paintings or studies, which will stand you in good stead when tackling a more ambitious subject.

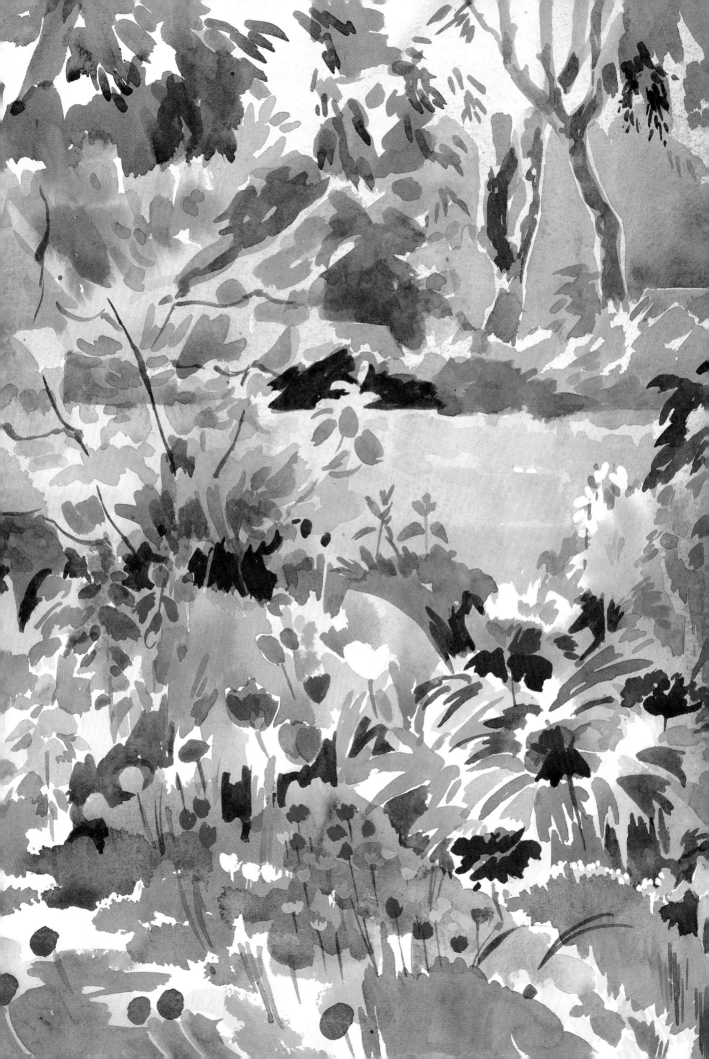

Summer

Summer steals up on you. Trees are suddenly in full leaf, there are geraniums for sale as well as numerous bedding plants – petunias, lobelia and alyssum are just a few. Hanging baskets appear as if by magic and you realise that it is light until 9.30pm. When does summer start? Certainly with the first cuckoo, some time in May.

Summer is a busy time for artists. The days are long and warm, and there can be no excuse for not painting as subjects abound in the hedgerows and gardens. Painting in your own garden is a pleasure – if you forget an essential piece of equipment it's not far away, and there is usually peace and quiet, but above all nature creates your subject. There is colour everywhere, from the brightest yellows and greens to the softest violets and pinks, and summer colours have a particular glow. There are warm and fiery reds of all kinds, crimsons and the palest pinks that we see in poppies and foxgloves. Delphiniums and campanula range from vivid to soft blues. As a contrast, there are white flowers with variations of tints: pink-white, white and palest green, white and yellow – it is not surprising that white gardens are so popular.

If the weather is unkind and you have to paint indoors, you could start by arranging a few flowers in an old teapot, or buttercups in a glass jar, roses in a silver bowl, or pansies in an eggcup.

I do not consider myself to be a serious gardener, but I do enjoy my garden and I grow certain plants which are a pleasure to paint, such as oriental poppies, which are placed near the path and easily accessible to paint. I also grow lilies and this year have planted them together with herbaceous plants to see how they combine, with a view to painting them later.

WILD FLOWERS

Some wild flowers are rare and many enthusiastic botanists are anxious to record the flower and its habitat. Many famous artists have done just this by recording in pencil and watercolour. It is easy to carry a miniature watercolour box with its own brush and water. While photographs are excellent records, painting has an especial value. The location will be firmly fixed in your mind, colour will be established and size recorded.

It is better not to pick wild flowers, but to paint them in situ. Record other details such as temperature, time and place in a notebook and diary. However, if you are painting wild flowers with a view to making a painting, you have to be aware of size, so suit your paper size to the size of the flower. Some wild flowers are small and delicate, and care needs to be taken when painting them. You might find that you need to use gouache for detail.

As with garden flowers, the moment has to be captured when you paint wild flowers. Try to be observant when walking in the countryside, as you

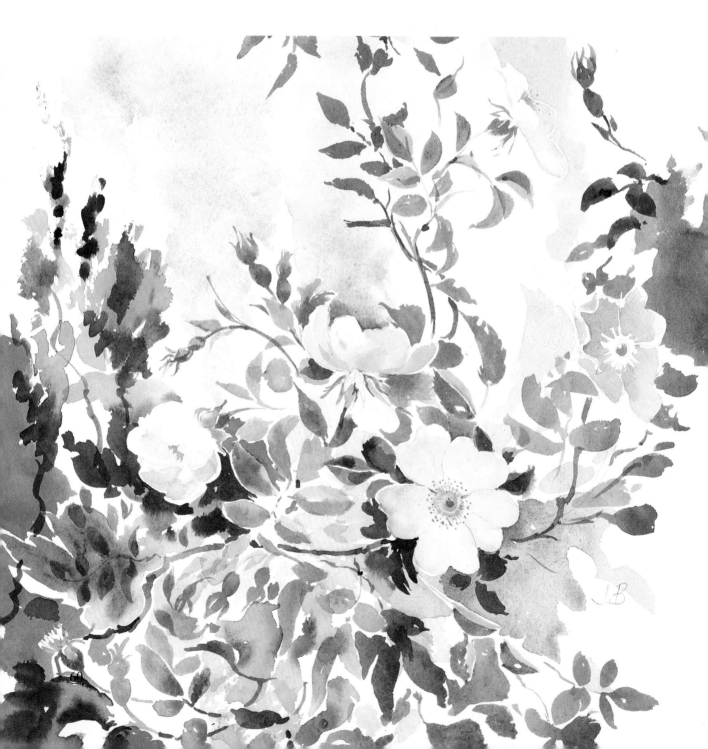

may have to wait another year before you get a second chance to paint a particular flower. Look out for the unusual and train your eye to be observant. As well as trying to be an artist, you need to be a botanist and gardener. Painting is often a matter of feeling and intuition about mixtures of colours and shapes. Students are sometimes amazed at what they can do given the right encouragement and a spark to fire their imagination.

◁ *WILD ROSES*
The delicate flowers of the wild rose are enchanting, but seem to grow in awkward places. I feel that this subject needs more study to get the best out of it, so this example could be the first study of many. Wild flowers are often very delicate and seem to need special treatment and care

△ *SCABIOUS*
Part of a large clump, the pretty light blue flowers of the scabious were attracting numerous bees. The flower heads are pleasant shapes. This flower on its delicate stem looks attractive in flower arrangements and when it is combined with garden flowers

◁ *THISTLE*
The thistle has striking flowers and is a very handsome plant; this study is just a small part of the whole. What a pity that the thistle is regarded as a weed. The flower heads almost require a gouache treatment, and one feels that pen work could help. A steel nib dipped in watercolour can help to achieve detail fairly easily. Beware of felt-tip pens as sometimes the ink discolours or runs if they are used with watercolour. Do ensure that your pen is waterproof

WILD GARDENS

It is one thing to see a wild garden at a flower show and quite another to have one yourself. Large areas of my garden are wild, not by design but simply because lack of time prevents tidier gardening. Buttercups, nettles, cowslips, honesty, bluebells, and ox-eye daisies grow without any encouragement. Some people have such a longing for order, tidiness and precision that a plea for a wild garden is not out of place. In urban and city areas, too, a natural garden would not be out of place. Recreation grounds and parks could also have a wild area instead of regimented rows of bedding plants. You have to have imagination to create a garden to attract butterflies, frogs and toads, apart from the bees and the birds.

Buttercups are magic flowers – so simple, so loved by children and such a glorious yellow. Try painting them in a jam-jar for simplicity, working out which yellows to use – perhaps you could put them with forget-me-nots. Try delicate wild pansies in an eggcup or yellow flags reflected in a pond, with a background of delicate ferns. There are so many combinations of plants that can add that extra dimension to your painting. The twisting honeysuckle with its scented flowers contrasts well with more formal plants. Wild flowers combined with garden flowers in vases or pots can create a welcome contrast. The early Dutch flower painters often used this combination to great advantage, adding insects and sometimes birds' nests.

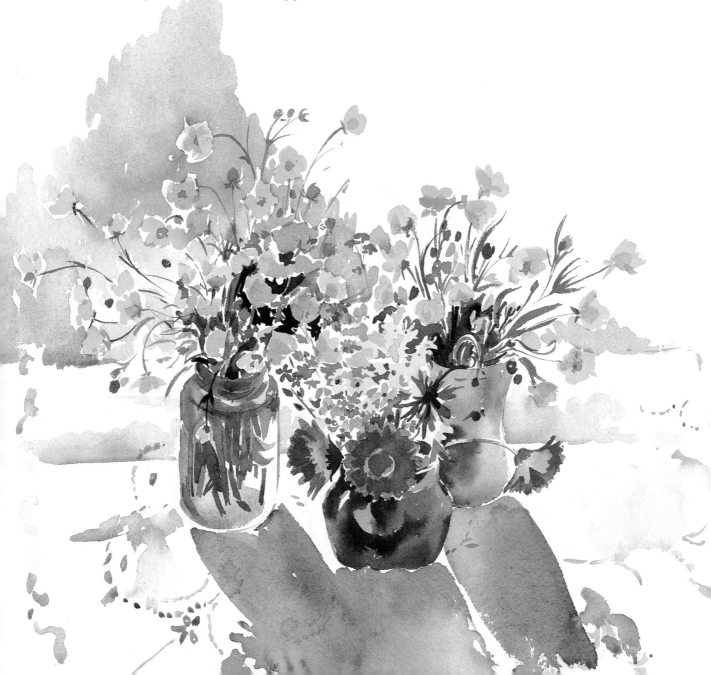

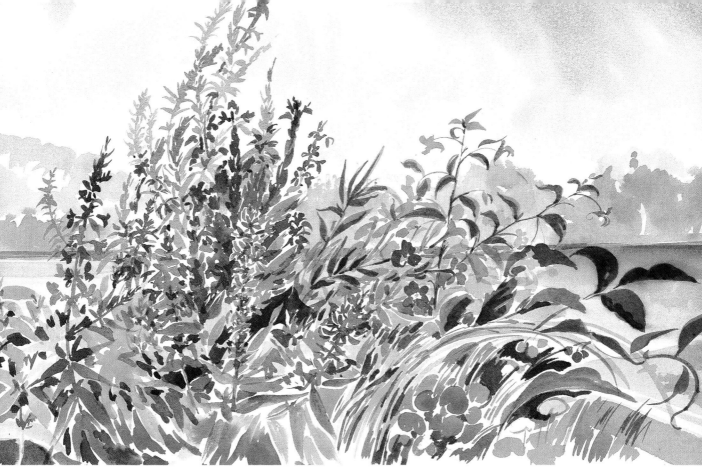

△ PURPLE LOOSESTRIFE

The purple loosestrife grows near rivers and damp places. Its flowers are very striking in colour but extremely fiddly to paint. River banks, on which yellow flags, Indian balsam, meadowsweet and other delightful wild flowers can be found are interesting places to paint. This purple loosestrife was painted on Whatman Hot Pressed 140lb paper to accommodate the small flowers and detail

▷ FOXGLOVES

These foxgloves were painted in situ while I was on holiday in North Wales. They were very abundant and grew in all the hedgerows and by the sides of walls. One problem in painting flowers as they grow is that it can be very uncomfortable perching halfway across a ditch knee-deep in nettles!

BUTTERCUPS (opposite page)

These buttercups were painted outside to take advantage of sunlight. A faint pencil indication of placing was made, and the buttercups were painted direct using gamboge. The charlock was painted in winsor yellow, which seemed a cold yellow in comparison to the gamboge. It was a very windy afternoon, so the buttercups were in constant motion. They are very delicate flowers and it was difficult to achieve the tonal differences. The background and tablecloth were put in last. The picture was painted on Arches Not 140lb

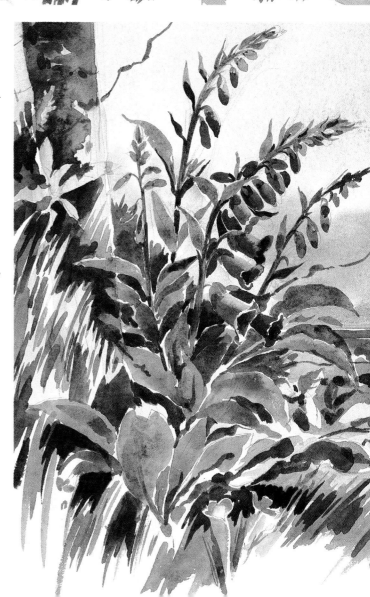

POPPIES

Oriental poppies are striking flowers. They are large and brilliant in colour and their paper-like petals are an invitation to the artist. Poppies are bold and call for a bold approach.

The painting overleaf was executed on Arches 140lb Rough and was painted straight in with my largest brush. The paper was dampened all over and a wash of ultramarine and brown madder was dropped in to create a sky. The flowers were indicated lightly in bright red and a light purple/blue background helped to indicate the cat-mint; to create a balance, permanent blue was included on

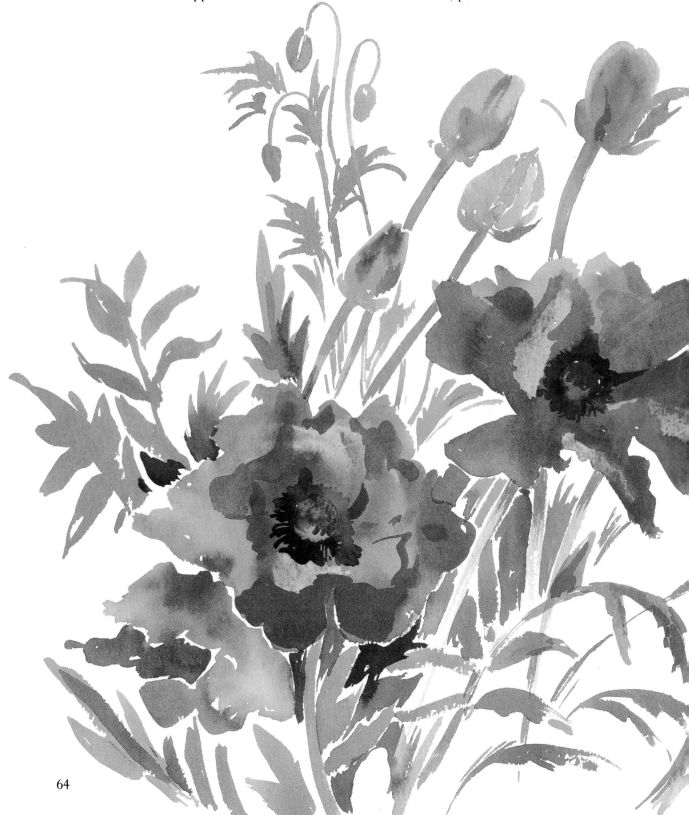

the left for the forget-me-nots. All this was done while the paper was damp – almost too damp, as at this point spots of rain appeared and I had to retreat.

I chose bright red for the poppies, which seemed to have the right amount of orange in it. Other reds were tried, including rose doré plus cadmium orange. Reds are sometimes difficult and care must be taken with the darker shades not to muddy them. The other plants were love-in-the-mist, honesty and cat-mint, with a few late forget-me-

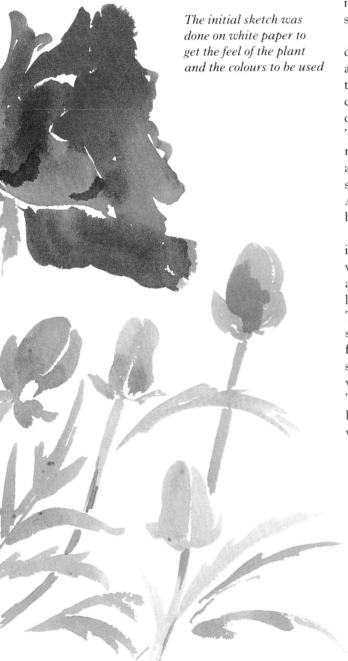

The initial sketch was done on white paper to get the feel of the plant and the colours to be used

nots. There had been heavy rain and a great deal of wind, causing most plants to fall or move around. In fact, if you look closely, rain spots can be observed on the painting.

There is a fair amount of detail to place, so the whole painting was pulled together with stalks, buds, leaves, etc. In fact, most of the painting is placed in readiness for a working up of colour and tone. Sometimes painting flowers in the garden means that it has to be woven together, following through stalks and leaves so that the painting makes some sort of order out of what can appear to be chaos. The shapes of the honesty and love-in-the-mist are intriguing and appear as little more than silhouettes.

Painting the poppies came next (painting on a dry surface). My initial placing created the light areas, so a stronger, more intense colour was used to create the darker tones and detail. The very dark centres were painted next, using ultramarine and crimson alizarin to make the darkest colour I could. This was fun, but I wasn't sure if the red was quite right. The poppies were such a brilliant colour against the dark green background that my next step was to strengthen other surrounding colours. As there was no sunshine, contrasts of colour had to be used to bring out the brilliance of the poppies.

Of course, there are no definite stages in a painting. The artist goes on evaluating the situation; you work on one area and then realise that this affects another, and so on. You stand back, walk away, look again, strengthen one piece, wash out another. The brush was used continuously to create the leaf shapes, details were added, parts that had been forgotten were completed, certain stalks were strengthened, leaves were added, and all the time I was trying to keep to the characters of the plants. The painting took about two-and-a-half to three hours, but I was influenced by the weather which was anything but kind.

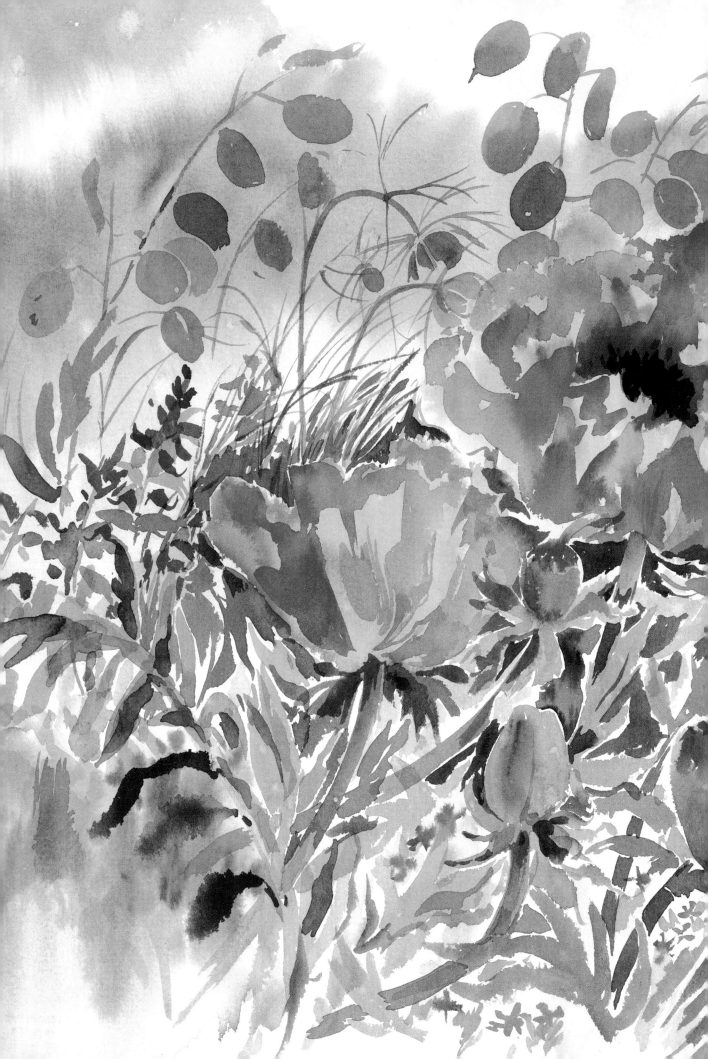

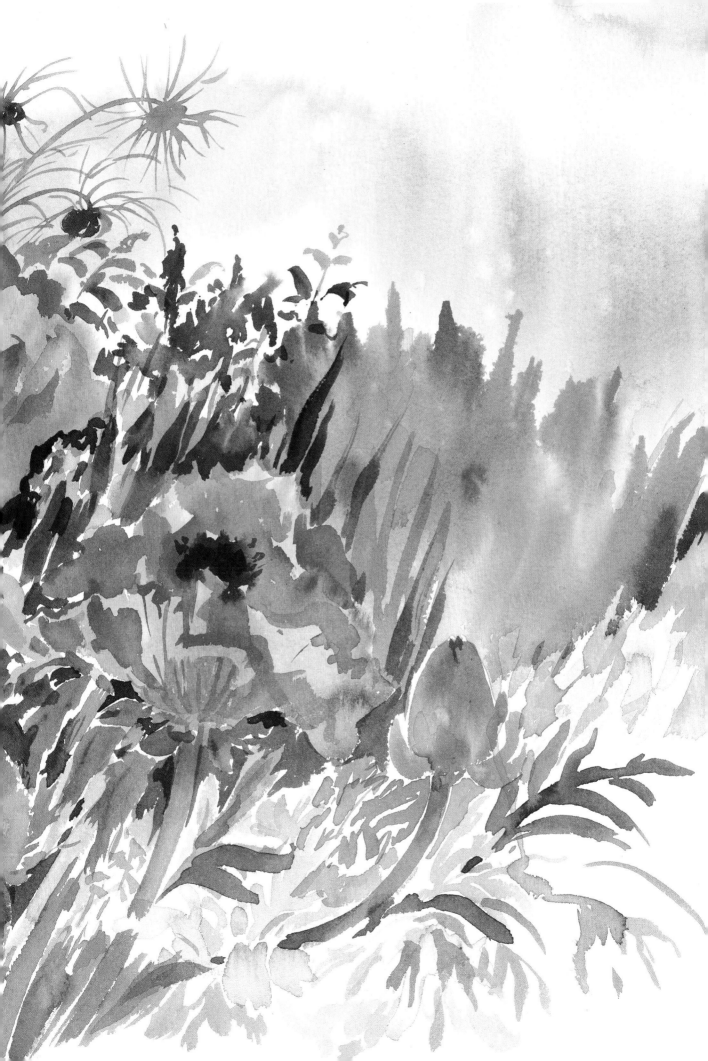

SUMMER VEGETABLES

The joy of fresh vegetables! To be able to wander in the garden in the summer is one of life's pleasures, and to be rewarded for hard work by succulent vegetables is an added bonus. It is possible to revel in the rich colours of these beetroot. They arranged themselves so gracefully on my table that I could not resist painting them, par-ticularly as alizarin crimson was such a prominent colour. Buying vegetables can also provide the stimulus to make you paint immediately, as you probably need to eat your vegetables for supper.

Painting on a white surface is always pleasing. Here the shapes were lightly drawn in with a brush, and the beets were painted, first using a wet-in-wet approach; the lines were taken out with folded blotting-paper. The stalks were rather interlaced and a muddle. The leaves were treated broadly as they had become limp and floppy. Small hairs on the roots were added in pencil. Again, the balance of looseness and accuracy has to be finely tuned to keep this kind of study looking fresh.

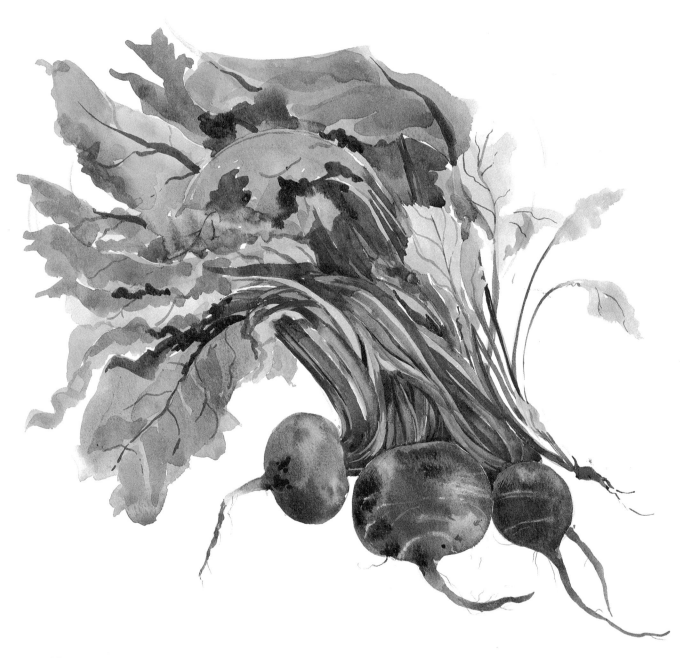

△ Herbs from the garden can provide a starting point. Leaf shapes are many and varied: fennel is feathery, while thyme is a very bright green. I have contrasted the greens of the leafy herb and the purple chive flowers with the delightful creaminess of the elder flower. It is very easy to forget various methods of painting, especially when you are deeply immersed in the subject but, if you can discipline yourself to consider technique before you start, and maybe make trial paintings, so much the better. I would suggest using a dry brush (as used for the elder blossom) and perhaps spatter work techniques, which could represent your subject in a more satisfactory and exciting way.

Alizarin crimson was used for the radishes. Advantage was taken of the play of light and dark shapes against each other. The leaves wilted fast, so I concentrated on the radishes

SUMMER FRUITS

RED AND BLACKCURRANTS

The currants had to be picked and painted before the birds took them. They are so small, so brilliant and some are transparent. How do you paint them, unless you are a miniaturist? I decided to take a leaf out of the way miniature painters work, and use a very smooth paper – 140lb Hot Pressed. This particular paper has a very smooth and hard surface, while some Hot Pressed papers are more absorbent. Where I live, fruit is sold in plastic boxes, so I couldn't find one of those little wooden punnets which look so delightful and are sympathetic colourwise. The colours used for the redcurrants were rose doré and crimson lake. The surface of Hot Pressed paper is quite different from Not or Rough paper, and is certainly not so agreeable for washes. The currants just tumbled out of the box and a simple composition appeared. The position

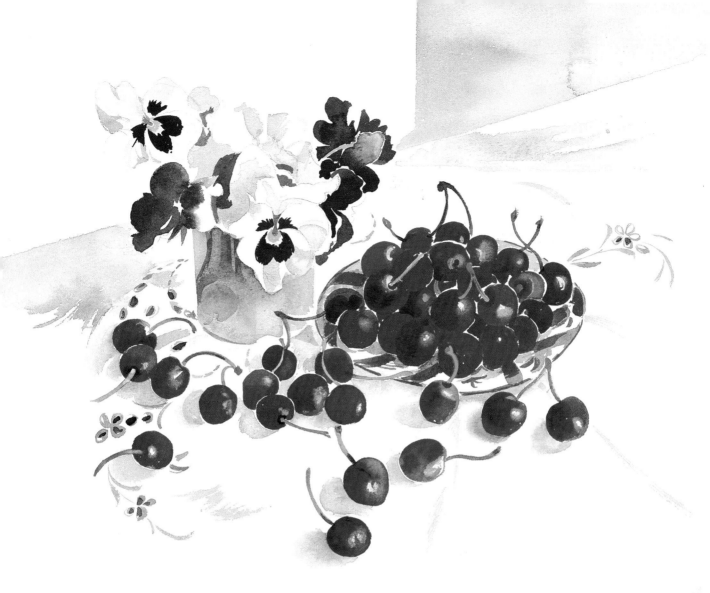

of the currants was indicated in pencil, then a few key currants were placed. It was difficult to portray the massed grouping of the fruit, so it was a painstaking painting of individual shapes.

STRAWBERRIES

The strawberries were painted with a mixture of alizarin crimson and winsor red, using hooker's green for the shadowed side. They were painted very wet – if the colour was too intense it was blotted off. Strawberries are often very shiny, and this effect is difficult to achieve. The indentations seem to appear either dark or light; often detail such as this requires a gouache treatment using solid colour. It was an interesting exercise.

As the strawberries in the basket were not grown in the garden, another study was made of strawberries actually growing – not such an easy exercise as one might think. There was a great deal of top growth, and the problem of the eye level was apparent: how much do you cheat? Student artists

PANSIES AND CHERRIES

This picture was painted indoors on a cool day. The main placings were put in pencil. The cherries were painted in a mixture of rose doré and crimson lake, and the highlights were achieved with a mixture of washing out and white gouache. In washing out, I dampened a brush and rubbed out the highlight, blotting out as I went. The different directions of the stalks were interesting. I felt that the pansies helped to give the painting scale, as well as providing a contrast to the bright reds of the cherries. Flowers and fruit often make a good combination. Painted on Arches 90lb Not. (Unfortunately, the cherries do not grow in my garden)

are often unaware of the amount of arranging that needs to be done before you are absolutely comfortable, both with your subject and physically. Sitting on the ground is an answer, but it gets very hard after the first hour. Comfortable garden seats are too large and small stools do not suit everyone.

PAINTING IN THE GARDEN

We have already discussed painting on location and the materials that you will need earlier in the book. Gardens abound with subjects from flowerpots to patios, but deciding on how and when to start needs thought. When to start is probably easier to solve as the flowers' immediacy is important, because the petals may blow away in the wind if you wait. How to begin is not so easy a task, so preparation is needed. Let me assume that you would like to paint the view down the garden and that you have checked the light. You then need to check that your eye level is right and that your viewing point is constant. It is easy to take too much in. Check whether you are looking along or up at the subject. Many flower painters prefer to look down on their subject, thus enabling the plant to fill the painting area. Looking along at your subject creates a natural appearance, but this can necessitate lying

on your stomach to paint, so a little cheating has to take place.

Painting in the garden in summer can be very exciting. Bright sunlight can define plant shapes wonderfully – for example, a pale yellow seed-head can be transformed when seen against dark shadow and colour can be sharpened and magnified. Achieving darks in watercolour can be difficult. A very dark dark can be made from crimson, indigo and hooker's green – the hue can be varied according to need. As already stated, a dark green can be made using prussian blue and burnt sienna. Use these colours full strength; if diluted, they become just another grey. (Mixed on the paper these

SHIRLEY POPPIES
The shirley poppies illustrated here were not painted in situ as it was not convenient. A few were picked, however, along with leaves and buds, and were formed into a pleasing arrangement. I was careful to follow the nature of the plants which in effect were painted in front of the subject. The colours were soft and a full range of pinks was used, from rose madder genuine to magenta and mauve

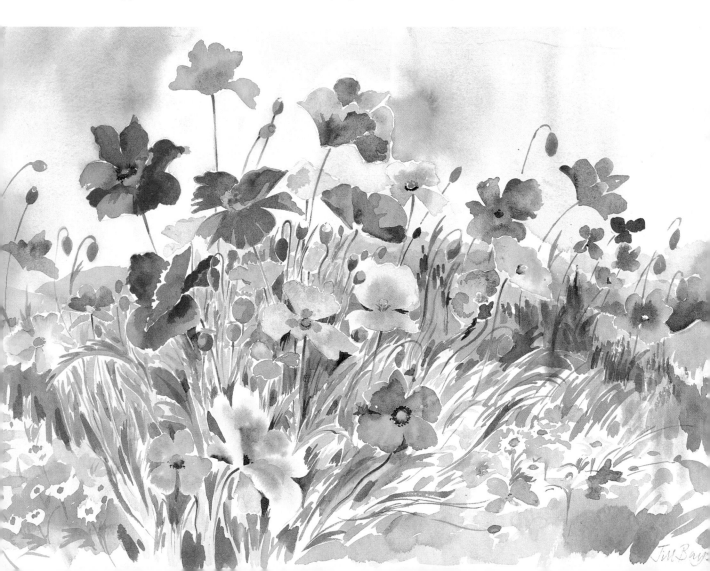

colours have more strength than when they are mixed in the palette.) Often the smallest area of very dark paint against a very light area can be all you need to make a contrasting accent. Sunlight and shadow are fascinating. Shadow areas need never be dull. They need to be studied, too. Are shadows on grass dark green or a grey tone on green? It does need to be thought about. Shadows on white can be warm or cool in tone, depending on what casts the shadow.

If you are painting on a dull day, however, contrasts have to be searched out. Perhaps this would be a reason for you to use more vibrant colours and to be aware of the more unusual variations of your complementary colours; there are many stunning unusual colour combinations, it just needs experimentation. You could try variations of red and green; as a start use pale pinks and dark greens, followed by dark reds and pale greens, so that your contrast can be dark/light as well as complementary.

Often when I am painting unsatisfactorily, I find

LOOKING DOWN THE GARDEN TO THE GREENHOUSE
This was painted in front of the subject. The light was variable as the sun was in and out, which tempted me to continue when I should have stopped. Paintings that are started in the morning should not be continued in the afternoon. This was a straightforward representation of the garden painted as a landscape – that is, sky first, then foreground, middle ground and detail in that order. The whole aspect was so green that it was difficult to search out variations in colour, in which case you have to rely on tonal differences

that my contrasts are weak, and greater effort has to be made to overcome this. Of course, paintings can be in a high or low key, but this does not mean that contrast must be ignored. Value scales can often be useful; the darkest value in your subject as well as the lightest one should also be noted.

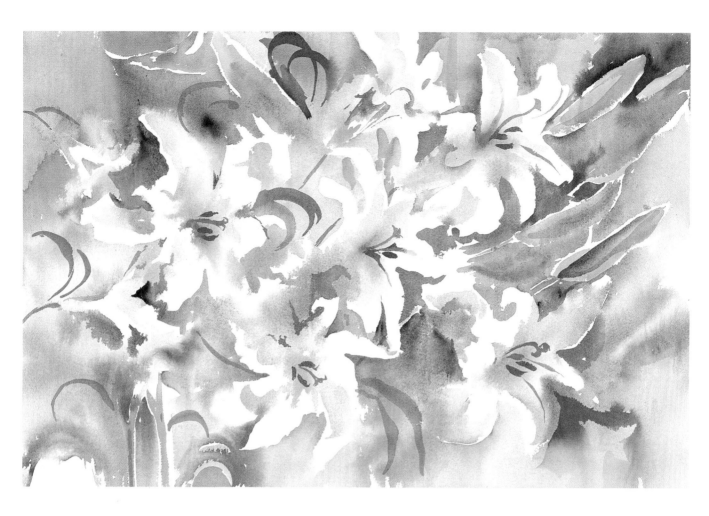

EXPLOITING THE MEDIUM

A rainy day can often spark off experimental work. A cold damp afternoon followed by rain produced this lily painting. I had intended to work outside, but, hampered by the weather, I used reference, imagination and colours that I do not usually use, and spent an enjoyable few hours refreshing my knowledge of the wet-into-wet method. Working on stretched Arches 140lb Rough paper, and almost immediately on a damp surface, I used rose madder genuine to indicate the shapes. Reference was to hand: I had several close-up photographs and a half Imperial painting completed last year before the subject that did not capture the beauty of these lovely regal lilies. It was too light and the composition was somehow awkward. After using the rose madder, it was mixed with ultra-marine for the grey tones, and a gradual build-up of the white shapes took place. Cadmium orange was used for the centres, and this was mixed with prussian blue for the greens. So, in effect, a limited palette was used: rose madder, ultramarine, cadmium orange and prussian blue, although a little winsor yellow and indigo were used. The paper stayed surprisingly damp but, being rough, hard edges were easier to find. This sort of work is not so possible with small shapes, but for sheer painting excitement this broad approach can not be beaten.

Experimenting in this way can often lead you into other flights of imagination. As a water-colourist, if my garden is not as I would like it, it is fairly simple to transform it on paper, using any of the tremendous variety of reference material that is available. Books on gardening with their superb photographs are such delights. Gardening programmes on television often offer such breath-taking aspects of flowers that the shots themselves resemble paintings. So let's be inspired, even if it has to be searched out and worked for.

AFTER THE RAIN

When the weather is bad and it has been impossible to go out into the garden, it's a relief when the sun shines and you can paint outside again. Pleasant colour arrangements in the garden often take several years to achieve, and gardeners must be very ruthless to pull up any plants whose colour jars on the eye. This is why painting is more satisfactory, as changes can be made either as you go along or at the start. My garden is full of horticultural mistakes, mostly because I cannot bear to part with something that has taken pains to grow and produce interesting buds, flowers or fruit which I can paint. This is the case with 'After the Rain', in which the purple candy tuft and orange marigolds are more pleasing than they looked in real life.

This large painting, 30 × 22in (762 × 559mm), was produced on Whatman 140lb Not. Because the paper was stretched, it was fairly easy to work in wet patches of colour to form some sort of composition early on. The idea was to convey drifts of colour. As there had been very heavy rain on and off for several days, most of the flowers were falling all over the place. After the initial washes (which faded very quickly), key positions were indicated lightly in grey, followed by more positive blocks of colour on individual flowers and leaves. As it was a larger work, it was carried out almost in an upright position, which meant that in the latter stages the paint was drier. In a painting of this kind you have to be fairly energetic in looking at the painting from a distance and then returning to work on it. It is easy to get close up and start to paint detail, and to forget the overall, broad watercolour feeling.

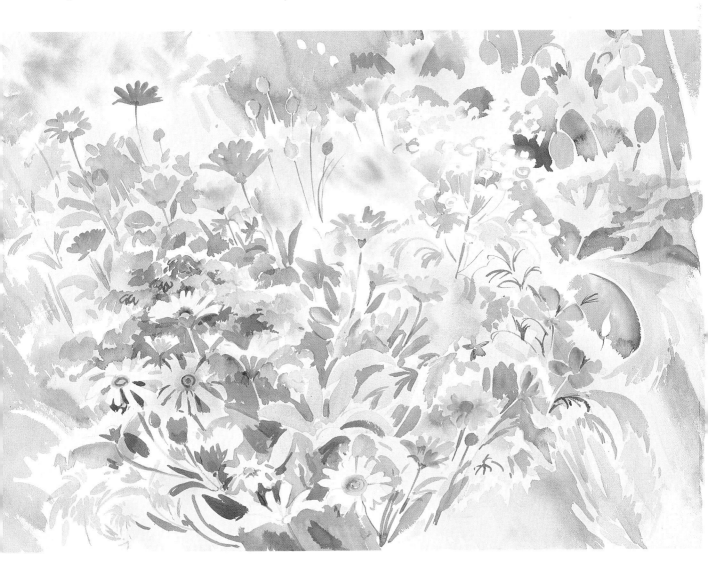

ROSES

Most artists who like painting flowers mention roses with a sigh and ask, 'How *do* you paint roses?' With their many petals curving and overlapping, care must be taken to retain the character of these lovely flowers. Sometimes it is a question of drawing them and asking fundamental questions such as the basic shape you are trying to portray.

In the painting illustrated below, I decided to be as accurate as possible with the drawing in order to familiarise myself with the nature of the rose in its various stages. These two lovely hybrid tea-roses have large firm flowers and exquisite buds which are a delight to paint. In making a study of this particular flower, it seemed a good idea initially to make a pencil drawing as the many curving petals were quite complicated. However, when painting them, an overall wash followed by detail and a certain amount of wet-into-wet work was made.

The paper used was Fabriano 140lb Not, which has a very pleasant surface which takes detail well.

Large, many-petalled flowers, such as dahlias and chrysanthemums, are often complicated and difficult to paint. It is easy to get lost in detail, but the main things to look for are the general direction of light and the mass of the flower. In comparison with the open rose, the buds, leaves and hips seemed simpler. The colours used were a mixture of aureolin and winsor red for the pink rose, and lemon yellow for the yellow rose. Cadmium orange was introduced on the buds which were very intense in colour. The usual green mixes were used for the leaves, but with blotting out and overpainting to achieve shininess and veins. This took some practice. If you continue to make roses a feature of your paintings, this kind of study will have its rewards in the nature of form and structure.

Many roses have delightfully shaped fruits (hips). Some hips are as attractive as the roses and make welcome additions to flower arrangements, providing colour and contrast.

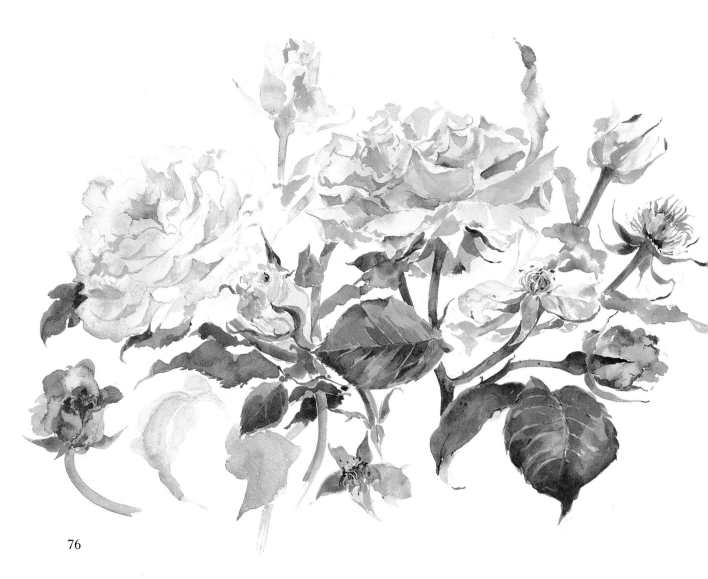

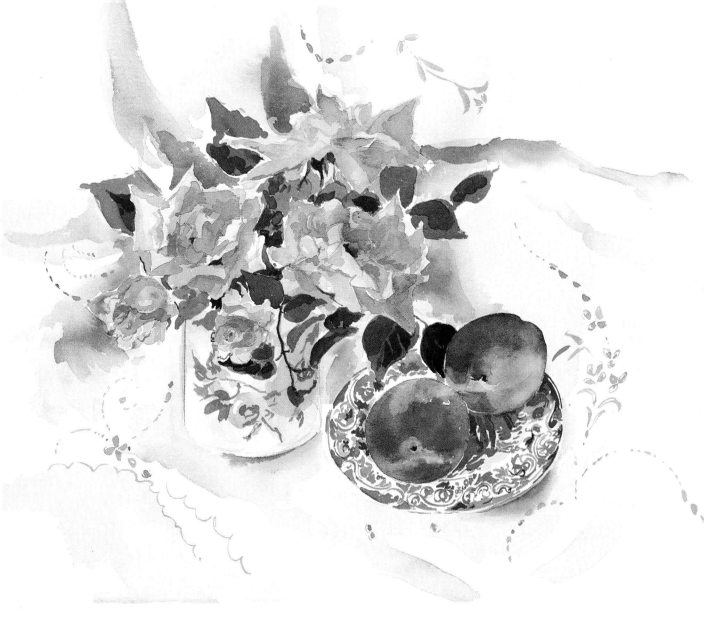

STILL LIFE

ROSES AND PEACHES

The pale apricot colour of these roses was accentuated by the soft pinks of the peaches – what an attractive combination and how difficult not to take a bite! Roses have such a variety of petals which interleave and curl back, that it is difficult to do them justice. The folded and embroidered cloth helped to give this simple still life movement and direction, and the blue and white china to set off the yellowy-orange colour scheme. Setting up a still life such as this requires some thought; peaches have to be bought and china found or borrowed, and light has to be considered. As with all painting, study pays, but in some instances it is not until the painting is completed that you know what should be done. It may be colour or tone that needs adjustment, or perhaps even the treatment. Having finished, you feel released and can use your brush freely; then you can see your values much more clearly.

Using your brush freely is a matter of temperament, training and time. Flexibility of hand and arm is also important, as is confidence in your drawing ability. Working on a small scale is not conducive to free brush work. Work large, stand at your easel and have a go. There are all kinds of techniques using watercolour, some requiring different degrees of finesse. You have to find your own level of pleasure and ability.

FLOWERS
IN THE
LANDSCAPE

In this landscape featuring a farmhouse nestling at the bottom of a gently sloping valley, flowers and foliage do not play a prominent part, yet they add a focus and direction to the composition as well as a scale. The few spots of red and mauve also create a contrast to the varied greens in the painting. Painting a landscape is not so vastly different from painting flowers; you have to tackle the subject in a logical way, and, as with other painting, make studies of sky, foliage, composition, etc, until you feel confident to tackle a complete painting in maybe a large size. My studio is full of experimental paintings – some I look at later, some are discarded, and some are recycled by using the back of the paper, or are washed out and used as backgrounds for other media, such as pastels. Incidentally, old watercolour paper makes a good ground when primed for painting in oils.

The choice of subject is up to you. For the

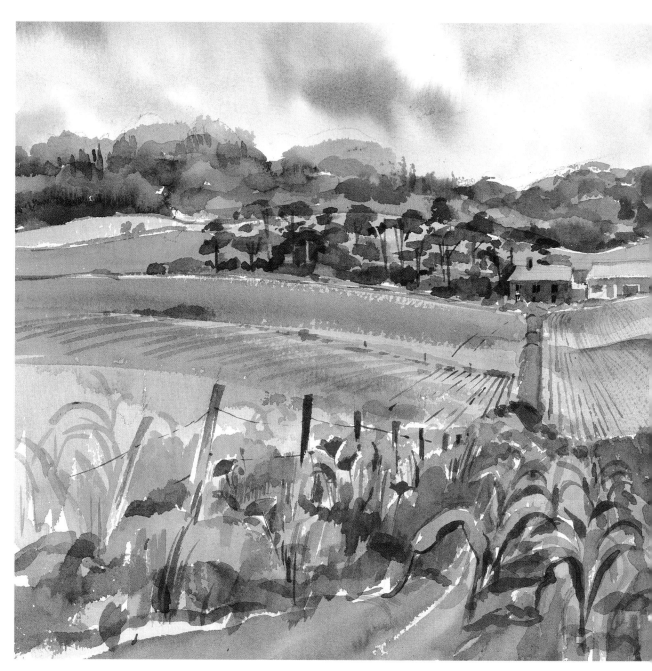

inexperienced artist, it is best to be simple and un-complicated in your choice. Painting landscapes on your own can be unnerving if you lack confidence, so go out with a friend or group so that you can exchange notes and compare the results. The time will soon come when you are out on your own and someone is sure to say, 'So you were the artist I saw the other day'. For the more experienced artist, landscapes should not present a problem, and if you want to give your composition more interest, try a few of the ideas mentioned earlier combined with unusual viewpoints – that is, looking at your subject through plants, or making your foreground register against the distance.

It is a good idea to set time aside to concentrate on getting a sky to look convincing, not only for landscape painting, but also as a background for a garden painting. Skies are often of a warm tone, and therefore cobalt plus brown madder can make a good basis, but you will find that there is use for cerulean blue, ultramarine and indigo, and this depends on time of year, the temperature and location

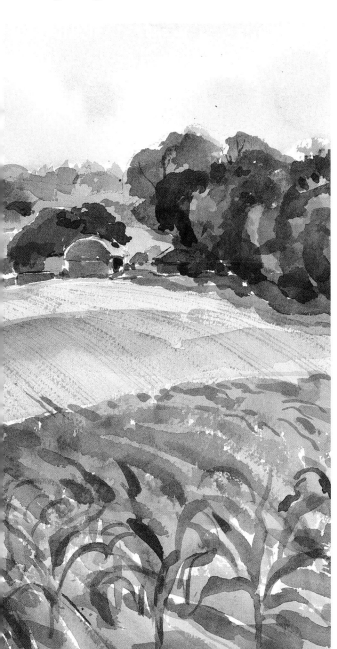

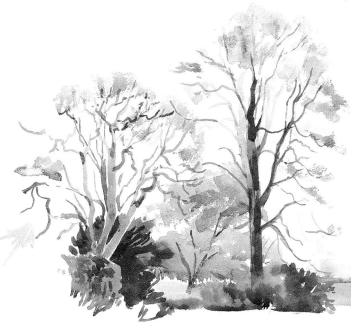

People often have difficulties painting trees, mainly because they haven't studied them enough. Learn to recognise a tree by its shape and colour, and know the shape of the leaf and type of trunk. Build up references of different species and learn how to represent leaves, twigs and branches by using your brushes in different ways – for example, use a dry-brush technique for the tops of trees

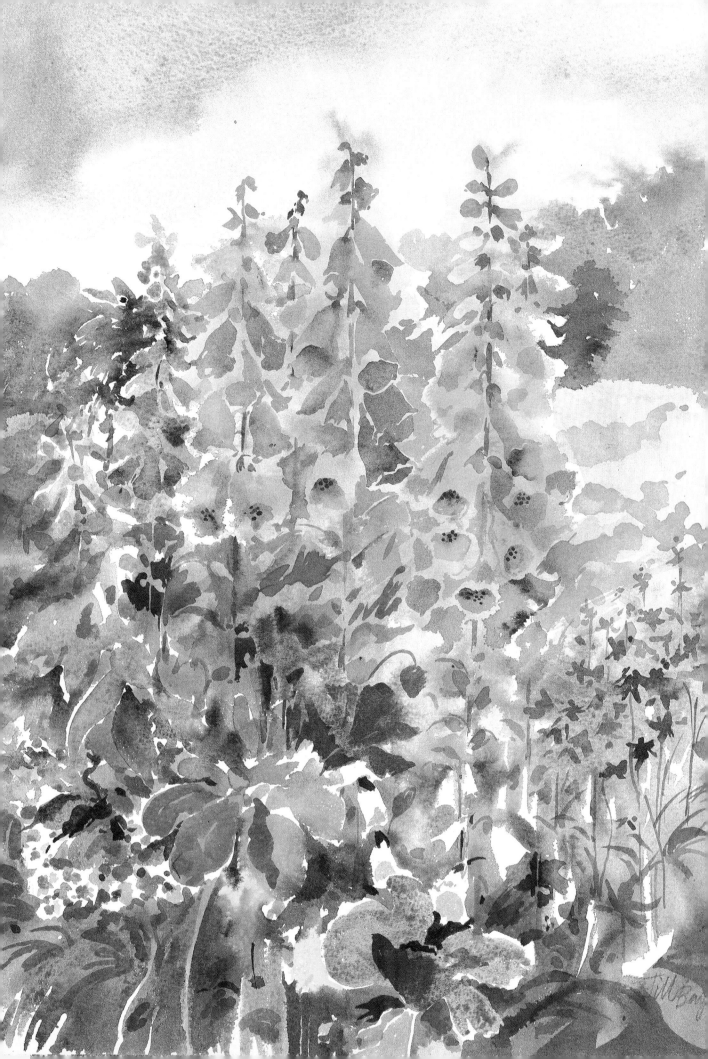

SUMMER
FLOWERS

▷ *GLADIOLI*
*This was painted upright to accommodate the tall
flowers. It was a comparatively simple painting of
the sky and then a wet-into-wet rendering of the
striking and reasonably simple shapes of the flowers*

◁ *FOXGLOVES*
*A kaleidoscope of colour, this upright painting was
started on very damp paper, the various flower shapes
being worked into as the paper dried. The idea of a
cottage garden appealed to me and I tried to capture
this feeling*

▽ *LOBELIA*
*There was no formal arrangement here – the plants,
flowers and foliage fell naturally. The lobelia was
painted first, and the other plants as they appeared.
Patience was needed with the small shapes, and
'light against dark' and 'dark against light' were
important points to remember. (The picture was
painted in a lovely garden in Dublin)*

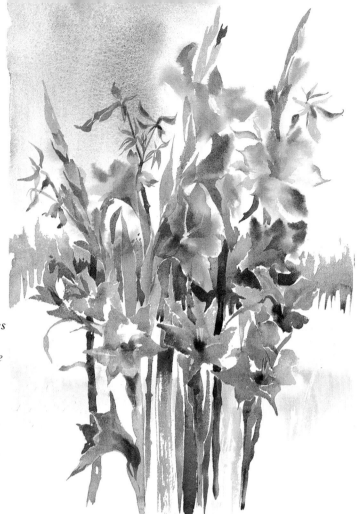

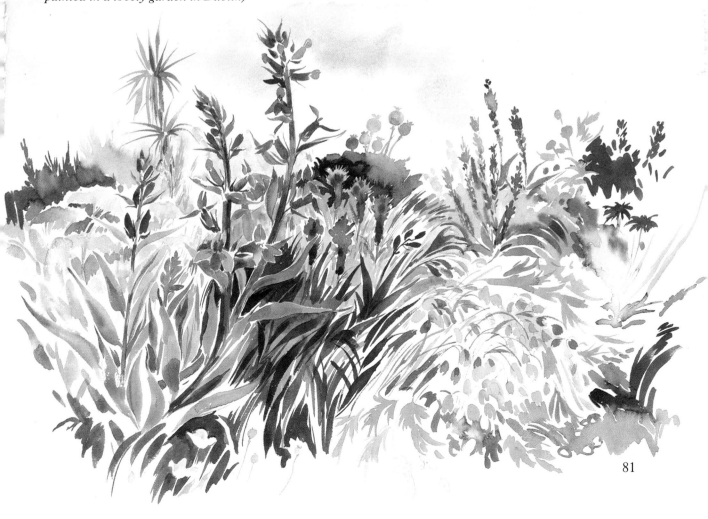

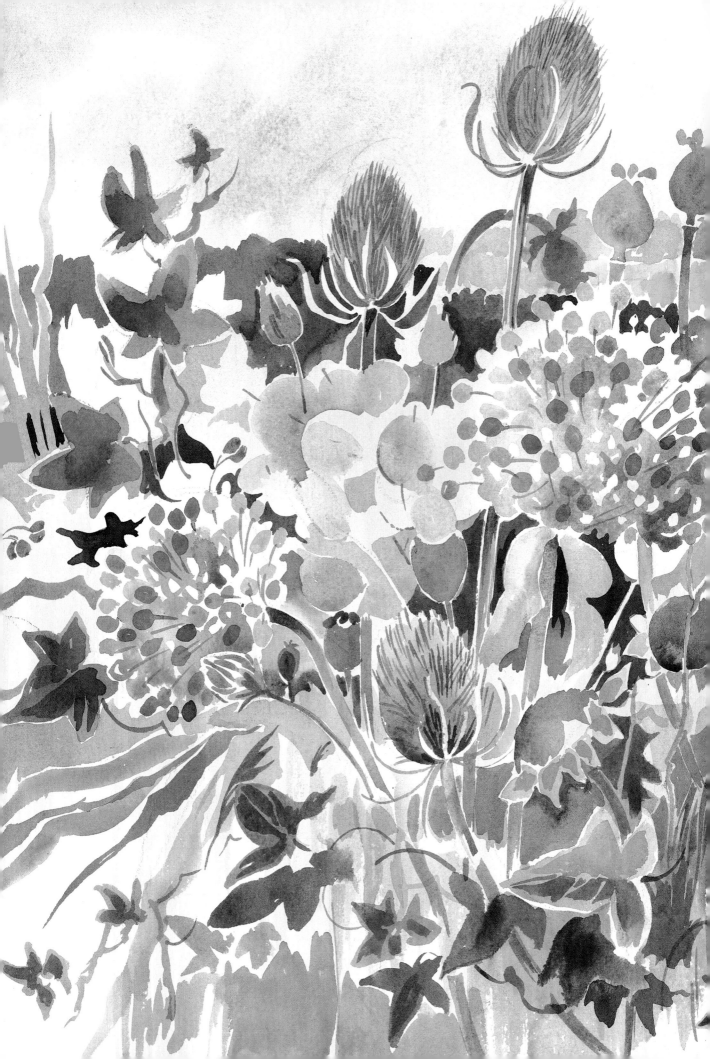

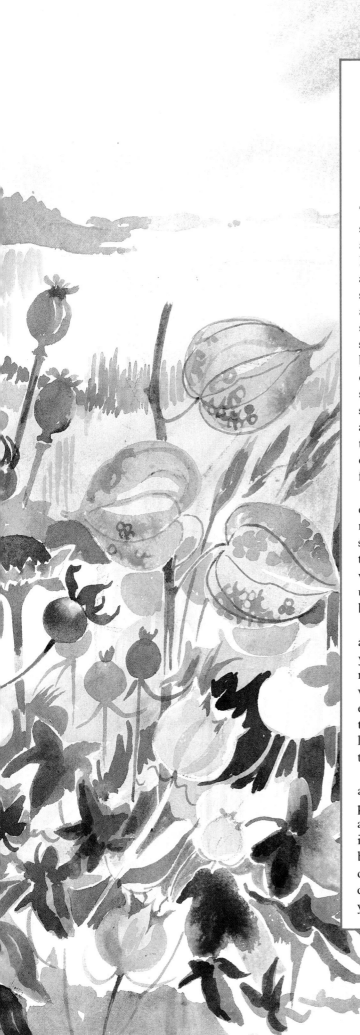

Autumn

The changeover of seasons is very subtle. In late summer there is often the hint of a change, such as a cold night, which can be a contrast to a brilliant sunny day. You suddenly realise that there are conkers on the chestnut trees, and that the seasons are passing too quickly. What do we associate with autumn? Sunny days, long dark shadows, a crispness in the air, a briskness in the step, long bean-pods, bright autumn flowers, berries and seeds. We have to hurry to achieve all our painting goals before the days become too short and cold to work outside. Autumn classes start, apples are ripe and there is a tremendous amount to do. As the evenings get shorter and the days become cooler, we are less and less inclined to paint outside and must look elsewhere for subjects.

Leaves are beautiful when they are turning colour, and epitomise autumn. Red-browns and russets can be interpreted by light red, burnt sienna and brown madder; browns can be portrayed by the coolness of raw umber and the warmth of burnt umber; browns combined with ultramarine or cobalt make subtle, useful greys, both warm and cool.

Early autumn is a continuation of summer, and it is not until the later apples are picked that you realise that it is late October and that frosts may be near. Of course, this varies according to where you live; in the North winter comes much earlier than in the South, and there can be two or three weeks' difference. However, wherever you live, the moment for painting is when you realise that the subject is here and now.

Subjects for painting should inspire the artist and it is the artist's interpretation that gives a painting that something extra. It is up to the artist to decide whether to paint in a certain way; if you are flamboyant, dash away with your brush with bold, bright colours; but if you decide that you want to emphasise, perhaps, contrasting colours, then that approach will be your personal choice.

SEEDS AND BERRIES

Seeds and berries abound in autumn and are often as fascinating as the flowers which preceded them. Elderberries and ivy make decorative additions to flower arrangements. We have noted already some of the various techniques which can be employed – wet on wet, lifting veins with blotting-paper, using different sized brushes to achieve different shapes, etc. Economy and speed combined with careful observation are essential when using watercolour. Professional artists work with surprising speed and efficiency. There appears to be no hesitation regarding shape or colour. This expertise comes from long and constant practice, and a subject which may take an amateur hours to complete is completed in half the time, by an experienced artist.

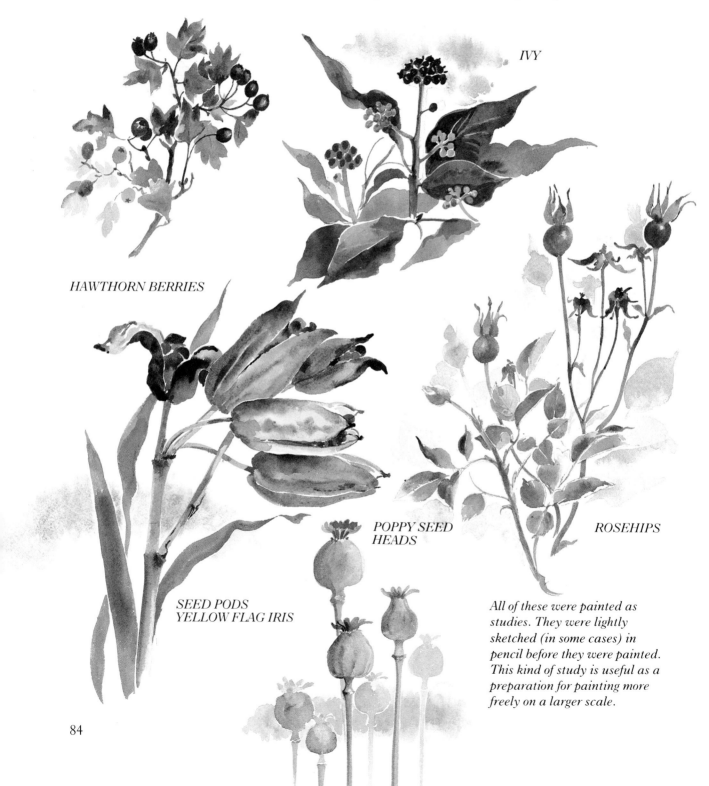

IVY

HAWTHORN BERRIES

POPPY SEED HEADS

ROSEHIPS

SEED PODS YELLOW FLAG IRIS

All of these were painted as studies. They were lightly sketched (in some cases) in pencil before they were painted. This kind of study is useful as a preparation for painting more freely on a larger scale.

BLACKBERRIES

These blackberries are known as 'Himalayan Giant'. This little study is straightforward, just a small spray of blackberries laid on paper; it is not very creative but it was a useful exercise

HORSE-CHESTNUTS

The rich yellows and browns of these lovely autumn colours gave me the chance to use cadmium yellow which often seems too brilliant and hard. The subject was laid out on a white surface so that it could be painted from above. Unless you are painting a specific still life, studies such as this are often more pleasing without table-tops and backgrounds. This painting is similar in size to the subject. When painting for reproduction purposes, artists always paint much larger than the finished printed subject matter appears, so be generous with your paper size and the brushes you use – throw away the No 00 and try a size 16!

You could start by lightly drawing in pencil the various positions of leaves and conkers. Proceed with your lightest colours and in sequence go on to your darkest tones. Check constantly that your colours correspond with the subject by holding up your work and comparing it to the original. This will give you an approximate guide for local colour, but you must not get confused with local colour and tonal values

USING CONTAINERS

A container is anything that will hold flowers, from an eggcup to a window-box – the choice is enormous. Containers such as earthenware pots can give structure to apparently unruly vegetation. Likewise, arches and fences can provide compositional direction. If you are housebound, as often happens in the winter or bad weather, different methods of displaying your subjects must be found. So many flower paintings fail because the composition shows lack of thought; tall flowers are placed centrally in narrow vases and the artist wonders why the painting looks dull and how the space around can be filled. 'How do you paint backgrounds?' is a familiar question.

Indoors, simple cups, jugs and glasses of all sizes are useful; small flowers look delightful in coffee cups and different sized containers can be used together to provide holders for different flowers; different heights and widths can be interesting. Small plants can be grown in almost anything. A teapot which has lost its lid can make a home for pansies or other flowers. Large decorative urns can make a focus point in a painting of a garden, particularly if it is casting strong shadows.

This painting portrays just a corner of the garden. It is slightly different from the paintings I often produce as it shows objects as one sees them – that is, not as a close-up but as they appear. In this case, I have chosen three or four flowerpots of a similar kind; these containers give the flowers height and interest. The tallest one is an old chimney-pot, and the others are ordinary flower-pots; the chimney-pot certainly adds height and interest to a dreary corner of the garden – for example, a corner which contains firewood, etc. The painting itself was a useful exercise as there was a lot of light and shade, and it was a good vehicle for practising my tonal values. I had to look very hard in some cases to differentiate between light and dark tones, and to see how I would represent the leaves.

Everything has been simplified in this painting – there is no great detail – and it was enjoyable to do. Most of the colours are the ones an artist normally holds in his or her palette, with the addition of magenta and some rose madder, and mauve. The greens were the variation of greens which I have described earlier. Of course, this kind of painting requires more careful drawing than, perhaps, a large wet-in-wet rendering of a geranium or suchlike. I have found that most artists have a preference for certain subjects. However, it is wise to develop your art by choosing a variety of subjects,

and corners of gardens and walls, doors, buildings, etc, are a good practice ground for painting.

I started with the lightest colours I could, which were the very light greens, a very light yellow ochre for the wall and a light red for the tiles, then I gradually built up to my darker colours. But it wasn't until I actually put in the darker colours that the painting began to read well. I can still see one or two patches where, maybe, a few extra touches would help, but it certainly is the juxtaposition of the darker areas with the light ones that helps to make a painting understandable.

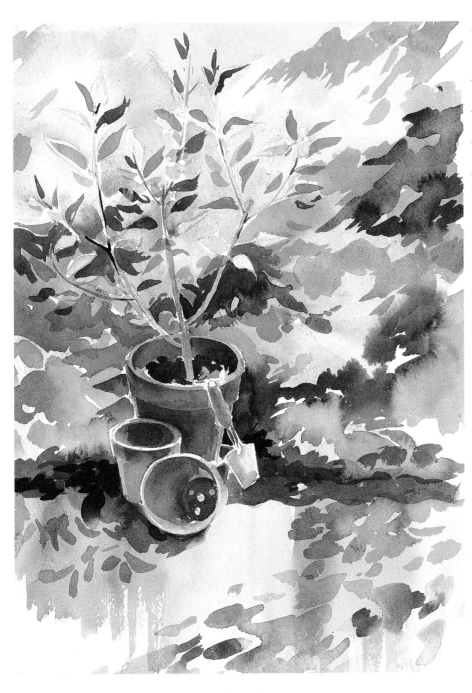

FLOWERPOTS
You can draw your pots in pencil first and then proceed to work from light to dark. In this particular case the pots were outside in the garden and the background to the painting was foliage. If you make a mistake, don't forget that it is comparatively easy to wash out the area with a sponge and clean water, and to start again. If you feel confident, indicate your shapes with a brush and then proceed to paint, noting your darkest areas as you go along

GARDEN
PAINTING

Early autumn can sometimes be very warm and it was a lovely day in September that prompted this garden scene. This kind of subject is often interpreted in other media, as watercolour generally needs to capture the essence of the scene on the day itself, and a subject such as this does not lend itself to being left for too long (it could rain!). This painting could be a good starting point for oils – after all, you have most of the necessary information: colour, pattern, arrangement. As it was, I used gouache; indeed, the painting could have been developed with more gouache which, as a medium, lends itself to overpainting,

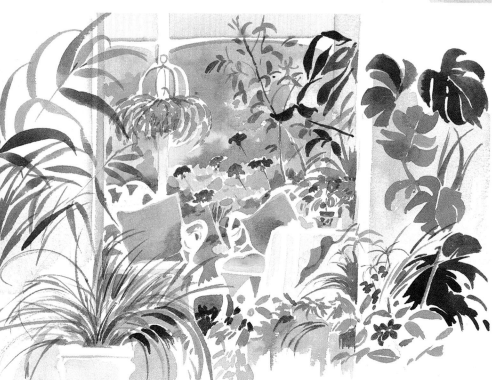

highlighting and defining.

Garden painting can portray many subjects – trees, plants, flowers, etc – but often other garden arrangements can be equally fascinating. We have already considered tables and chairs, but other garden items, such as wheelbarrows and watering-cans, can be satisfying to paint, and indeed, they often add a focus; fences and gates can also add structure. In the well-ordered gardens of the last century and before, every view and vista was considered to be worthy of a vantage point; perhaps we should be more conscious of this in our own gardens and become landscape gardeners as well as landscape and flower painters. The idea of creating beauty on any scale is intriguing and should be investigated.

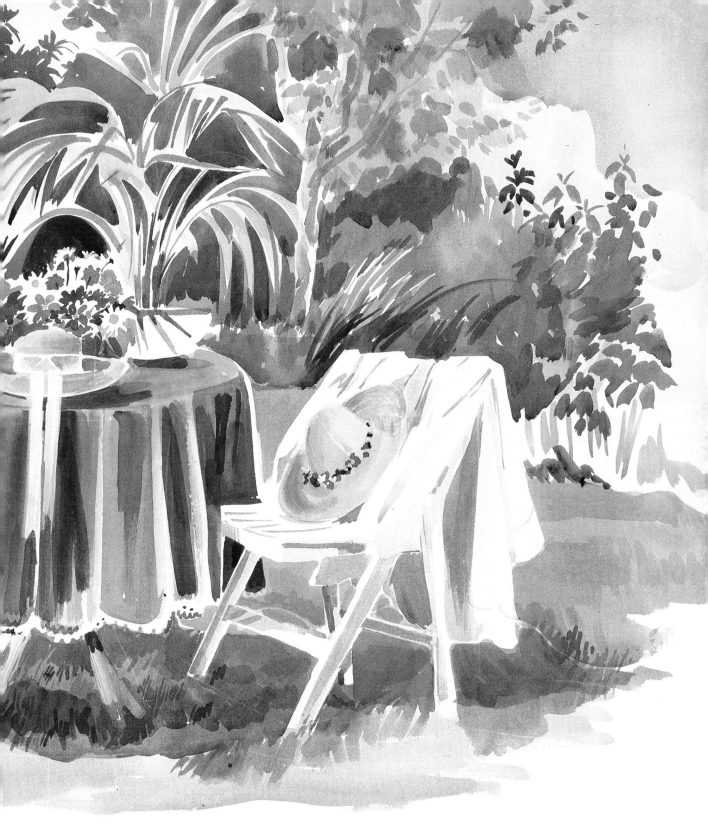

CONSERVATORY PAINTING

If you are fortunate enough to possess a conservatory,
it can provide many possible subjects, particularly
on wet days. This small painting, 15 × 10in (381 ×
254mm), is of my neighbour's conservatory which,
although small, is cunningly enlarged with mirrors.
In fact, the picture is a reflection in the mirror. The
elegant white chairs were left as the white paper and

painted around. It was a case of painting the light
shapes first – that is, the broad masses – and the
linear detail and leaf shapes last. The pink cushions
were the right contrast for the various leafy greens.
The paper was Arches Not 90lb stretched and the
colours used were those of my normal palette. Subjects
such as this are usually intriguing because the
onlooker is unperceived

INTERIORS

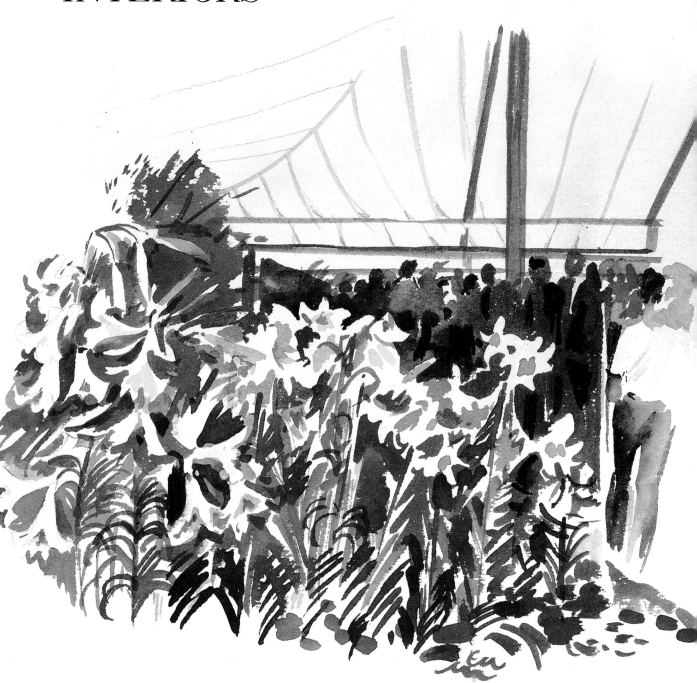

'CHELSEA FLOWER SHOW'
This small sketch, 8 × 10in (203 × 254mm), was made from an even smaller pencil sketch made at the show itself. The lilies were breathtaking and quite overshadowed the slowly moving onlookers. There is a particular sort of atmosphere in large marquees; the light is very diffused and quiet, which seems to make the flowers appear even more brilliant. The composition was based on a very definite diagonal, and the tonal contrast of the light lilies and the dark people is particularly marked. It is interesting to use sketch-book studies such as this as a prelude to a more finished piece of work. There are certain alterations to be made which are less difficult at this stage than later. You can also play around with different masking arrangements. In this particular case, I have plenty of references for the regale lilies, which is very convenient, and feel confident about the next stage, which would be a larger painting incorporating some changes

The word 'interior' conveys to me the cool, quiet paintings of Vermeer, but there can be many interpretations of interiors. It could be the crowded breakfast table, the bunch of white marguerites hastily put in a marmalade jar, or the carefully arranged flowerpiece in your window. Your interior can be quiet or fussy, it can be an expression of your own self, your own room with sunlight streaming in on a bunch of mimosa that you bought to brighten up a dull corner. But above all the interior can be the vehicle for painting. You can put so much into it – people, furniture, windows, doors – there is no end to the intriguing possibilities that the idea of painting an interior affords. Being indoors, the subject can remain in situ for as long as you like; it can be spontaneous or it can be pre-arranged.

Your interiors need not necessarily be painted in your own home. Flower shows held in marquees are one possibility. Many subjects can be found inside greenhouses, both large and small, and in temperate and tropical houses; many stately homes have conservatory areas which have interesting subjects for the artist. It can be enough to take notes and then to work on your painting later; this is difficult to do and requires plenty of information, whether in the form of sketches, colour notes or photographs. Garden sheds offer a wealth of subjects – flowerpots, garden tools, watering-cans are all genuine shapes which cry out to be painted, either with or without plants.

Windows can give structure to an otherwise shapeless mass of flowers and foliage by providing horizontals and uprights, and also by containing shapes. Objects arranged against windows can give interesting back-lighting effects.

There are many examples of paintings which show views through windows or still lifes before a window, and it is the juxtaposition and contrast of inside and outside which is interesting. Two artists who often painted interiors in intriguing ways are Pierre Bonnard and Edouard Vuillard.

Often a view within a view, or a picture within a picture, can be employed to great advantage. Views through doorways, arches, pillars, etc are intriguing; they are useful devices for the artist. Of course, if you are looking through an arch it is a good idea to have something to look at rather than an empty space framed by flowers. If you feel your painting needs livening up, consider the use of cast shadows, contrast of tone and unusual viewpoints. Although most subjects have been tackled before, there is always a new way of presenting your subject.

MOOD

The ideas behind a painting can be intriguing. Sometimes, when you see a particular image, you ask what was it that made the artist paint that particular subject. The idea behind some paintings is obvious – for example, a portrait painting, which can be a record or a rendering of a loved one at a particular moment. It can be simply the charm of the subject, the colour or the fascination for the artist of a particular arrangement of shapes. Particular lighting effects are exciting, or maybe it was just the artist's joy in using his or her paint. But whatever the reason for the painting's existence, there must be some feeling behind it.

Painting is enjoyable and often therapeutic; it can also be fascinating and frustrating at the same time. Often, a subject started as an exercise can intrigue you in an inexplicable way. We see examples of this in the paintings of everyday objects, such as those used in still-life painting. The artist can seek to emphasise certain aspects of an arrangement; qualities of stillness and serenity can be brought out just as forcefully as qualities emphasised by bold colour and vigorous brush work. Whilst the painter can be instrumental in creating certain feelings in a painting, through exploiting colour and light, often the accidental arrangement can be just as satisfying – foxgloves growing in a secluded corner or light playing on bluebells in late spring.

Your own mood has a great deal to do with the kind of painting you produce. Also, the artist in yourself can influence the 'mood' of the painting by the colours used, by its composition and by the subject matter. The 'feeling' of the painting can be the result of many factors, and a variety of adjectives can be used to describe the mood of a painting – for example, lively, quiet, soft, peaceful, harmonious, striking, colourful, bright, direct.

These are all thoughts to be aware of when painting. Mostly they are unconscious, but if you wish to convey certain feelings about your subject, be aware of the moods that colour can give. Certain colours create mood. Silvery greys are calm, as are the pale lemon-yellows. Reds are more strident. Blues can be regal. Colours can suggest the season in which the subject was painted. Patterns can also convey moods – the use of certain patterned fabrics such as drapes or curtains can enhance your colour scheme. These ideas are exploited by artists and examples can be seen in many paintings.

FUNGI

Mushrooms and toadstools seem to spring up at any time of the year in my garden. These include enormous horse mushrooms and puffballs, and there are shaggy ink caps and fairy bonnets. Under silver birch grow the beautiful yet poisonous fly agaric which is bright red and spotted. There are many reliable reference books which you can study if you feel doubtful about any. Being sure of your subject can help your enjoyment; sometimes you can use unusual and intriguing subjects as studies and for reference, perhaps to include in future paintings. Straightforward recording of everyday plants is extremely useful, but unusual plants can encourage you to experiment with pattern and colour. Many designers use natural objects as starting points for their ideas, and many artists look to growing forms for inspiration.

It is not possible to paint fungi in situ as they grow too close to the ground, so they have to be picked and carefully carried home and painted straightaway. There are various situations in which fungi can look attractive as a still life. You can simulate the natural woodland or pasture, or they can look interesting arranged in various rustic baskets, or in kitchen settings with a chopping-board, vegetables and saucepans. Like many natural subjects, they must be painted straight-away, which means that your materials have to be ready for use, including, if possible, stretched paper on boards.

▽ *WOOD BLEWITT*
This is hardly an autumnal painting as this mushroom was found (to my surprise) after Christmas, but it is included here. Again, it was plucked and brought indoors and painted before the background on a handy piece of stretched Bockingford. It was painted the same size as the original. The colour was unusual – purple-red, rich and dark, particularly the one which was pushing through the earth – quite sinister. Normal methods of painting were used, but the background was left grey and white in a calligraphic manner

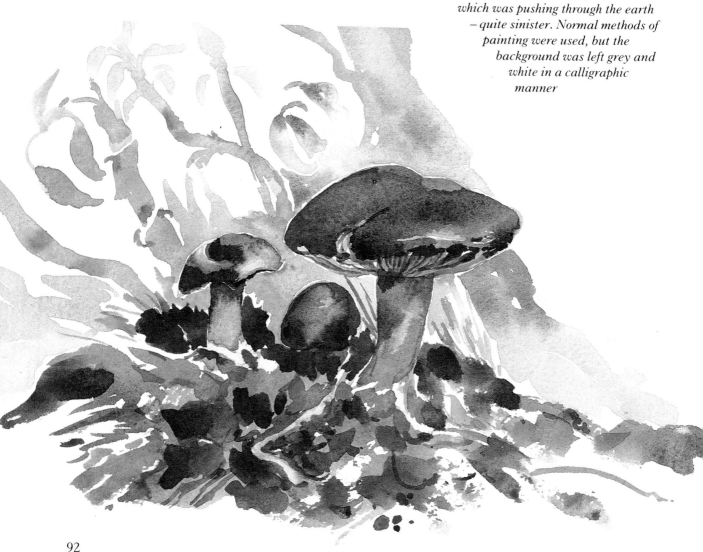

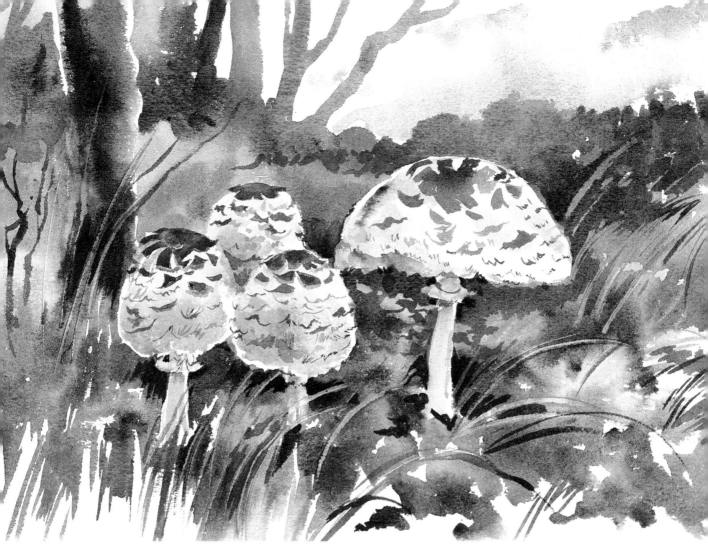

△ PARASOL MUSHROOMS
These delicious mushrooms were found under horse-chestnut trees. This little painting was contrived. The mushrooms were painted first and a suitable imaginary background and situation was contrived from sketchbooks, etc. As the paper was stretched, it was possible to make the background washes wet and fluid to suggest an autumnal wood. When the paint was nearly dry, the end of a brush was used to scrape or scratch out light grasses. (The paint has to be of the right strength and consistency for scraping out. It is a good idea to practise first)

▽ HORSE MUSHROOMS
These large open mushrooms were painted as a quick sketch just before they opened out flat. First I did a pale wash drawing of the mushrooms to show their shape, then some washes and lastly a detailed drawing with a pen and watercolour. The pen has a steel nib which is capable of a lively line, both thick and thin, unlike most fibre-tip pens which create a monotonous line of even thickness

93

AUTUMN FRUIT AND VEGETABLES

A great deal of this autumn section is about painting berries and fruits, and using different reds. Red is nature's ideal colour as it contrasts so beautifully with green. In one artists' materials catalogue there were no fewer than sixteen watercolour reds, and this does not include the brown reds, such as light red, brown madder or venetian red. So which red should you use? Some reds are browner in tone, using iron as a base, but they have certain individual properties. For instance, indian red tends to be bluer, whereas light red is brighter. The alizarin

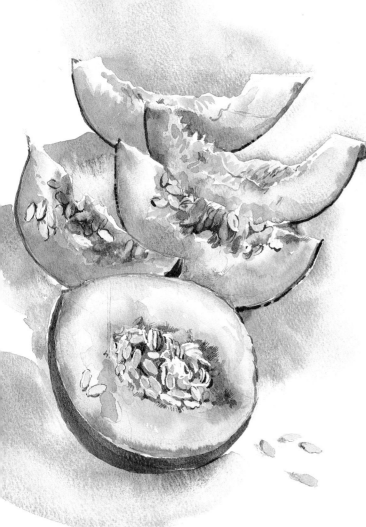

colours are brilliant and rosy, and cadmium reds are bright and more opaque.

Some reds mix well with blue to make purple, while others do not, so you must practise to find out which is which. Generally speaking, it is not necessary to be too concerned over the constituents of pigments, but it is wise to know the differences between reds – that is, whether they are bluer or browner, etc. Different paint manufacturers often produce named colours which are derived from pigments we already know – that is, bright red, winsor red, etc. (Incidentally, vermilion, which is· expensive, has been largely superseded by cadmium.)

MELON

This melon provided strong, positive curves, which made an interesting pattern. There are many ways in which this subject could have been arranged, but I decided to look down on the melon and to make the light come from the right; consequently the sections of the melon formed a light, dark, light, dark pattern as each part came in front of the other. The picture was painted the same size as the subject on Bockingford 140lb. It was lightly sketched in pencil with some of the seeds drawn in with masking fluid so that I could easily paint over these small shapes. First, the background was painted with a grey wash made of ultramarine and brown madder. The lighter parts of the melon were painted next and washed in with a pale green, ochre and yellow, very wet in wet. As the inside of the melon was very pale (including the seeds), it was difficult to achieve definition, and detail was drawn in with watercolour and a steel nib. Cadmium orange was employed to give a lift to the wishy-washy colour.

APPLES

Painting apples must be one of the first exercises that artists tackle. Try painting in different ways. Start with overlaying your colour, quite deliberately, but making sure that each wash dries before the next one. Or you could paint wet in wet and hope to control the washes. I use a mixture of the two methods, controlling and adjusting as I go.

The apples painted in this illustration were completed in front of the subject. The situation was right: it was a lovely warm day and the apples looked inviting. I liked the idea of leaves, etc silhouetted against a white wall. Various decisions had to be made about the composition as a vertical

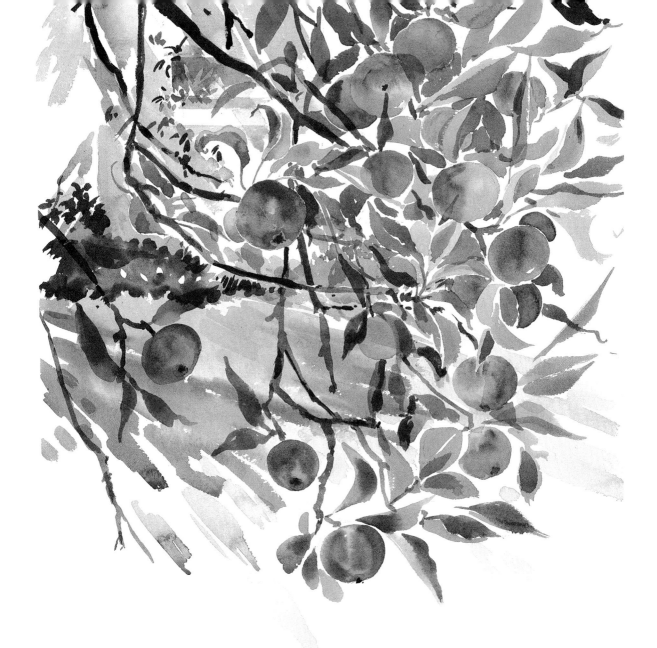

format seemed to suit the subject. The positioning of the apples was lightly sketched in pencil on 140lb Arches paper, the scale being the same as the subject. Decisions must be made regarding lighting, as it is surprising how quickly the sun moves in an hour or two. You must also decide whether you would like to achieve the 'impression' of the subject – that is, to keep it loose and free or to make it precise. In some ways, it is harder to achieve the 'impression' as it has to be just right.

Winsor red was used for the apples, which were painted first, but it was difficult to achieve the correct depth of colour. Next came the leaves, using winsor yellow and ultramarine with a touch of burnt sienna. When painting outdoors, there are many factors to contend with – not least the wind, which blows everything around. It is easy to get lost, so you have to be inventive and not worry if

something, a leaf for instance, does not remain in the same place. So in tackling this kind of subject, you need to be sure of your techniques and colour; it is not for the inexperienced, faint-hearted or slow artist.

Other factors can be tricky – for instance, if you have preconceived ideas about colour. It would be natural to think that green leaves are darker than a white wall, whereas, in some instances, the leaves with light on them appear to be lighter than the white wall in shadow. These are all interesting problems for the painter.

This picture was painted mainly using a No 8 brush, but smaller stems, etc were put in with a No 4. I imagine that if I tackled this subject again, I would make alterations in the procedure. Perhaps the whole background could have been painted first rather than parts of it.

AUTUMN LEAVES

For some artists the changing colours of autumn signal a greater awareness of the possibilities of painting. With the fall of the autumn leaves, artists will bring out their watercolours, for who can resist those lovely pinks, browns, yellows and ochres? These colours seem so different from the yellows and greens of spring, and from the reds, purples and blues of summer. They are rich, satisfying colours that are so obvious – they need no mixing, no experimentation; they are rich and true, straight from the tube; there are no excuses for getting them wrong. Try them out, from full strength – that is, saturated – to the palest of tints. Leave your tint to dry and then overpaint with another autumnal colour and see the rich effects. Leaves can be so satisfying to paint, so obligingly still, yet curved, and with jagged edges that can be helpful to the novice painter.

With this in mind, this watercolour evolved as a kind of sampler on which artists can practise their techniques, use their brushes, and become more familiar with certain colours. I used 140lb Fabriano Not paper, a No 8 and a No 4 sable brush and my normal palette. The leaves themselves can be arranged on a sheet of paper so that you can work in a controlled manner. There are still problems of tone and form to be resolved, and in some ways the drawing can be difficult. It is best to have a variety of leaves, in size, colour and shape, and if necessary they can be drawn lightly in pencil first. There need be very little overlapping of any kind, unless you wish. Careful observation is the key to this kind of painting. One of the main features is the veins, which are invariably light in colour and this gives the clue to the first wash.

▽ *THE FIRST STAGE*
The subject was drawn in carefully, but lightly, in pencil. Next came the lightest wash which eventually became the veins. The colour varied according to the leaf being painted, and with the smaller leaf with no particular difference of shapes, a wet-in-wet technique was possible. If necessary, paint the larger leaf section by section

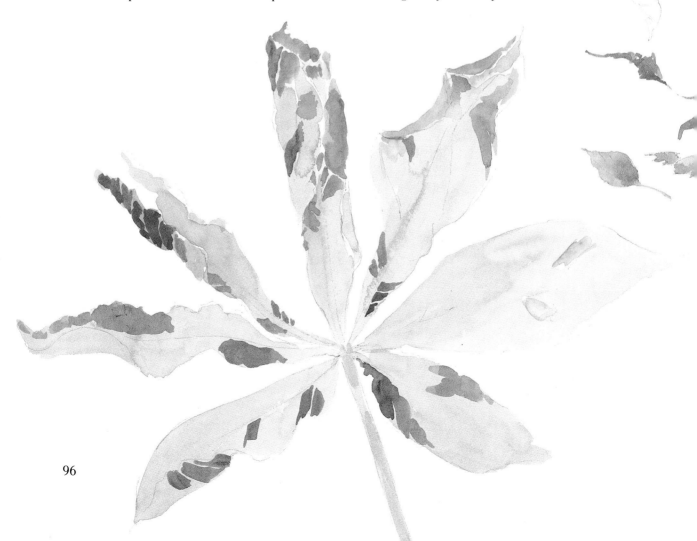

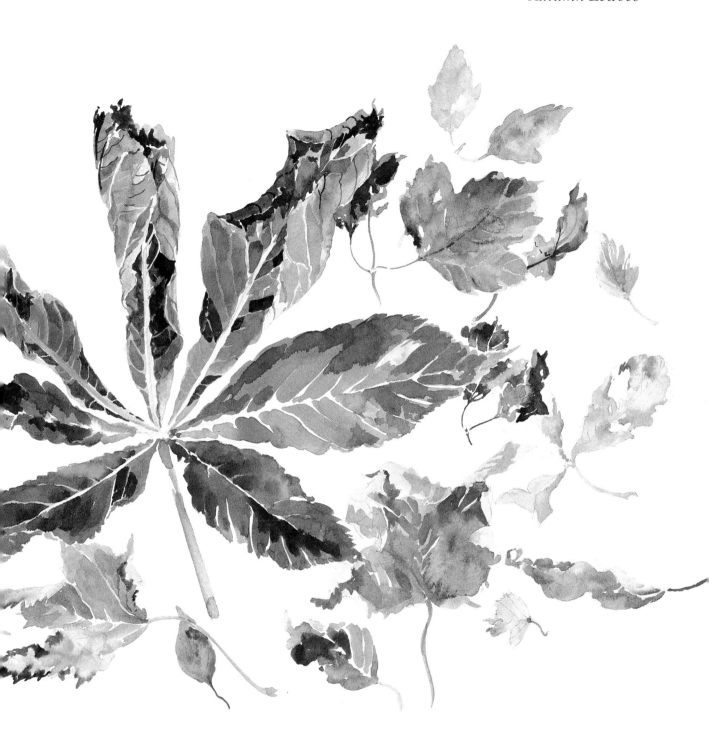

△ COMPLETION

If, as in the case of the horse-chestnut leaf, you can see a definite darker tone, paint this in. This is obvious in the second leaf section of the horse-chestnut. If there are lighter parts, these could be placed, but take care when changing colour. As I have often said before, breaking down your tones to light, medium and dark can be very helpful, and this can apply to any colour

This kind of composition or arrangement can be adapted to suit many flowers or plants and is the easiest way for beginners. However, do try to paint your subject life size in order to learn more about the watercolour technique. Most amateur artists paint on surprisingly small pieces of paper – whether through nervousness or meanness, I don't know – and wonder why the results look cramped and poky. Think big, be daring and have fun with your painting

YELLOW DAHLIAS

You can gather many different flowers until late into the autumn; here there are cosmos, fuchsia, jasmine, feverfew and tobacco plant, as well as dahlias. There is no apparent structure, no vase, but you can detect a north, south, east and west axis. In arrangements of this kind, or if you are painting an apparently unruly mass in the garden,

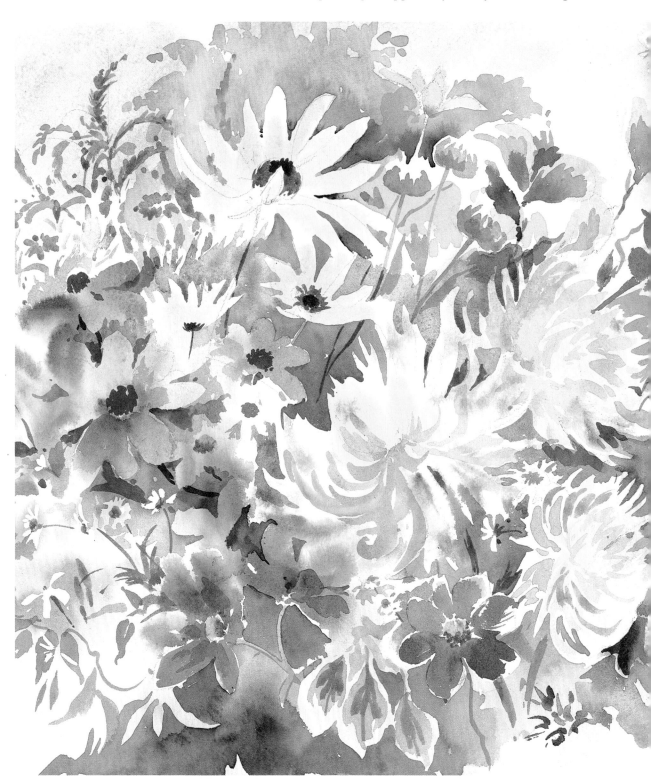

it is important to give some sort of structure or unity to the painting. This painting is a good example of negative shapes and the way they are held in space by the use of a darker background. Also, this shows how a wet-in-wet technique has been sharpened and developed.

Artists nearly always favour particular colours and feel happier using them. Yellow is a difficult colour to use, and care must be taken to find the right shade. Experiment with yellows to find the one that matches the flower, and try to remember the differences between aureolin and winsor yellow, for example, or between gamboge and cadmium. Ask yourself questions – for example, what kind of strength would you need to mix for the brightest nasturtium? how pale is lemon yellow? is it cool or warm? Such experiments and practice sessions are invaluable. As you carry through your studies, your eye will develop and be able to discern, and an individual approach will be apparent.

The idea of painting a cluster of flowers as a mass is useful. If you are painting hydrangeas or geraniums, which have smallish flowers that bloom simultaneously in groups, consider using a mass of colour, which can be put down on damp paper, and letting the colour run and spread, either to a defined shape or haphazardly. You can then pick out individual flowers by blotting out or painting in, and define the edges by darker tones and shapes.

You will find that the initial washes can easily be strengthened, if needed, by redamping the area. If you are painting on a good tough paper, the surface will take a certain amount of reworking, particularly if it is stretched. During the autumn and winter, time is often available to practise putting down washes in all kinds of ways, so that when the better weather appears you will know exactly how to tackle your subject when you are in front of it.

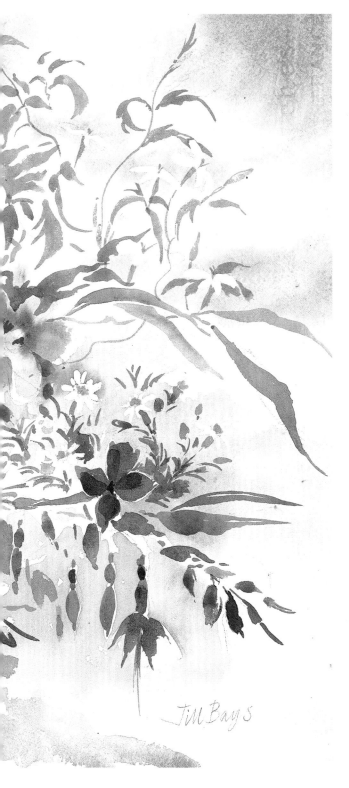

AUTUMN BERRIES

When you paint red fruits and berries you are constantly perplexed about which red to use. There are so many reds, but in order to be precise when painting flowers, fruits, berries, etc, you will get to the stage when it is essential to have the right one. You will need at least a choice of orange, red and crimson. Vermilion and cadmium red are useful, but expensive.

It would be best to paint all fruits and flowers in situ, but this is not always possible because you may find that you need either to paint from the top of steps or to lie on the ground to get the best from your subject. So frequently the subject has to be picked and put in a more suitable position for you to paint it. Ideally, flower or garden painters (particularly watercolourists) should start painting as early as possible in the day. Flowers move and turn round almost before your eyes, so if you prevaricate, all is lost and you will have to start again the next day. You will not have this problem if you paint in situ; furthermore, your subject will not fade as quickly as when it is picked. It is very pleasing to want to paint a subject; your mouth waters in anticipation and you can't wait to get started! I felt like this about painting the rosehips; they were so round, red and luscious. I only wished there had been enough time to make a full-sized painting. As it was, all I could hope to do was to try to make the hips as lifelike as possible.

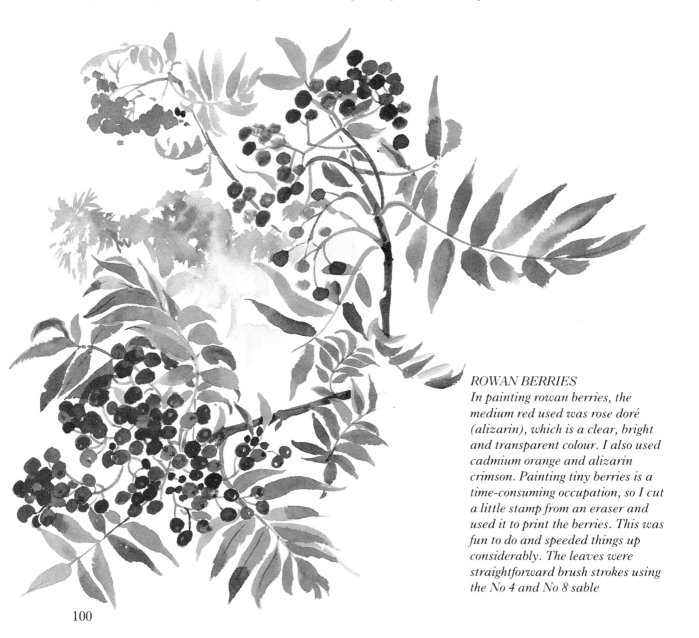

ROWAN BERRIES
In painting rowan berries, the medium red used was rose doré (alizarin), which is a clear, bright and transparent colour. I also used cadmium orange and alizarin crimson. Painting tiny berries is a time-consuming occupation, so I cut a little stamp from an eraser and used it to print the berries. This was fun to do and speeded things up considerably. The leaves were straightforward brush strokes using the No 4 and No 8 sable

▷ ROSEHIPS

Rosehips come in all shapes and sizes – large and small, fat and thin, and vary from orange-red to black-purple. Unless you are a vigorous pruner, they can be a welcome colourful addition to your autumn garden. They can enhance flower arrangements and are often in evidence until the first hard frosts.

These are Rosa rugosa alba. *The flower is single and white and the plant produces particularly large hips, often at the same time as the flowers. Their beauty is only slightly marred by the vast amount of thorns, so be careful when picking them*

▽ ELDERBERRIES

As this was a study, I started by drawing one of the elderberry heads in pencil. However, this proved to be very time-consuming, so I started to paint straightaway, holding the elderberry twig up in front of me and trying to paint it exactly as I saw it – in fact, as it would hang on the tree. I used my normal method of light, medium and dark greens for the stalks and leaves. I didn't put too much detail into the leaves as I was keen to achieve the overall effect.

Painting these little berries was not a very speedy process, and I had to devise a way of how to do so. First, the colour was the darkest dark colour that I could find, but I did include black. I used ultramarine and alizarin crimson, plus a touch of black, in varying strengths. I started by laboriously painting each berry, but quickly realised that the way I paint I needed a faster solution. So, after cutting off the ends of various brushes and pencils, and trying all sorts of ways of stamping the colour, I found that a pencil with a rubber on the end was the easiest way to 'print' the berries. Having discovered this, I made much faster progress, and although it wasn't a very regular shape, it was a help

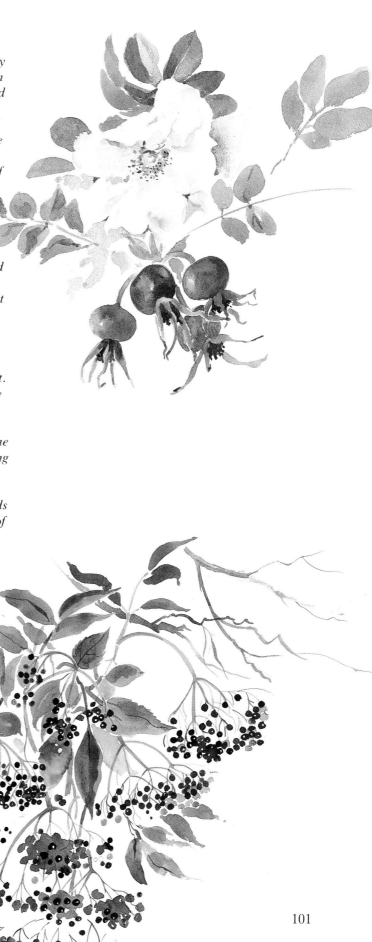

101

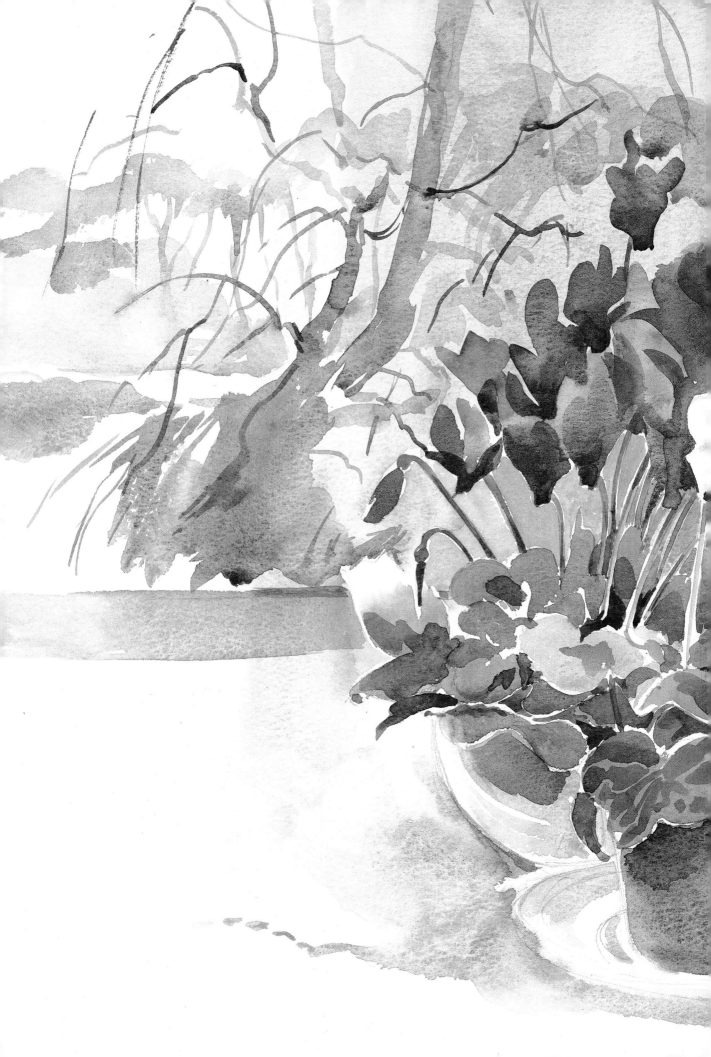

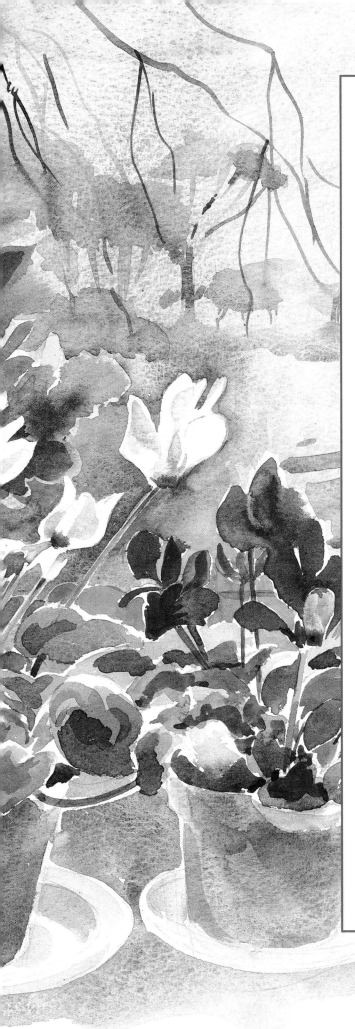

Winter

The days shorten, Christmas draws closer, but flower shops and nurseries still have flowering plants. One of my favourite plants is the cyclamen; massed together, its flowers make a stunning and vivid display. It is often difficult to find subjects at this time of the year, but in early winter a variety of seed-heads will provide interesting subjects.

While you are out walking you can usually find unusual subjects – for example, fir cones – which you can gather and bring home to paint, and there are plenty of evergreens to pick. Ivy is very decorative and can be painted in all kinds of ways, as an addition or as a painting study in its own right. Winter can be exciting – skies are often full of drama and bare branches are easier to paint than those that are full of leaves. Sometimes as an added bonus there is snow, when your house becomes strangely bright with reflected light and you can't resist the idea of painting a snowy landscape.

The spare colours of winter are hard to describe. The green of winter is strong against silver-grey skies; gorse and ivy contrast with the parchment-like colours of dried honesty and silver birch trees. As artists, we must take advantage of nature's colour combinations and reflect these in our palettes.

Flower shops are full of exotic flowers which can make fascinating studies, but a cheaper alternative are flowers that you have dried yourself. If you remember to plant your winter-flowering bulbs early enough, you will be rewarded with paper-white narcissi or hyacinths in charming blues and pinks. Nature is always generous. There are delicate apricot begonias to be painted and sometimes the fragile *Iris unguicularis* appears just after Christmas. Winter vegetables are very good subjects for the artist: the delicate colours of a swede, the drama of leeks and pale curling celery, and onions are full of the richest browns and ochres.

A WINTER STILL LIFE

Painting flowers on their own is a delightful experience, but when they are in a vase it is often appropriate to combine them with fruit or china, or to include other objects to enhance your painting. This kind of arranging can take some time and doubts can creep in as to whether the composition is pleasing or not. Eye levels are worth considering, as what is pleasing from one angle may not be pleasing from another; sometimes more than one drawing or painting has to be made before you arrive at a decision. Often I find that a high viewpoint is preferable, but this is a matter of opinion. Imagination can play a large part in the composition of your painting, particularly in winter when it is impossible to work outside. It can be useful to include architectural features such as windows or doors, or fabrics can be added. It is helpful to keep a reference library of features which you can find interesting.

▽ *NARCISSI AND PEARS*
This was such an interesting still life that I painted it again the next day from a higher viewpoint (right) and used my paper vertically. This painting was the second version of a subject that intrigued me. The washes were floated in on the Rough Arches paper while it was still wet from stretching. The colour was unmixed and I made a conscious effort to use the primary colours for brightness – in this case rose madder genuine, cadmium yellow pale and ultramarine. The general colour of the narcissi was very loosely brushed in and the table and bowl were indicated in a pale grey. Everything was left to dry before I tackled the pears and satsumas and detail on the flowers. As the general drift of the flowers was already indicated, I had simply to paint around the flower shapes and define the rest of the leaves. This took some time. My main concern was to preserve the freshness of the painting while being precise

Painting daffodils is marvellous practice for using yellow. Turner had at least nine yellows in his palette. Work straightaway with your brush – don't be tempted to use a pencil. The excitement of starting a painting in watercolour is thrilling. Use your colour tonally and try not to mix it. The colour will run and mix on the paper to form the loveliest tints

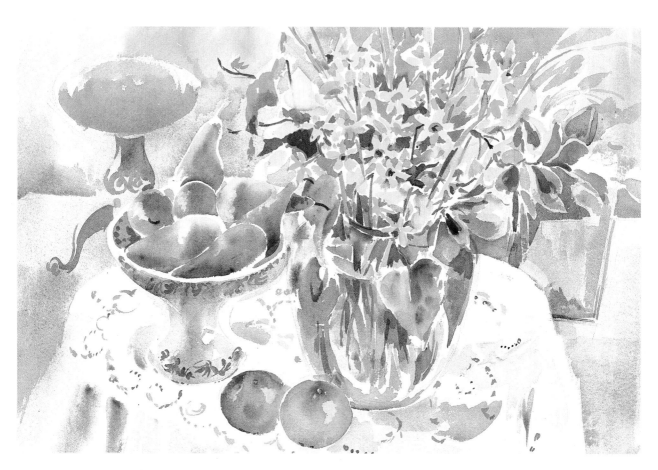

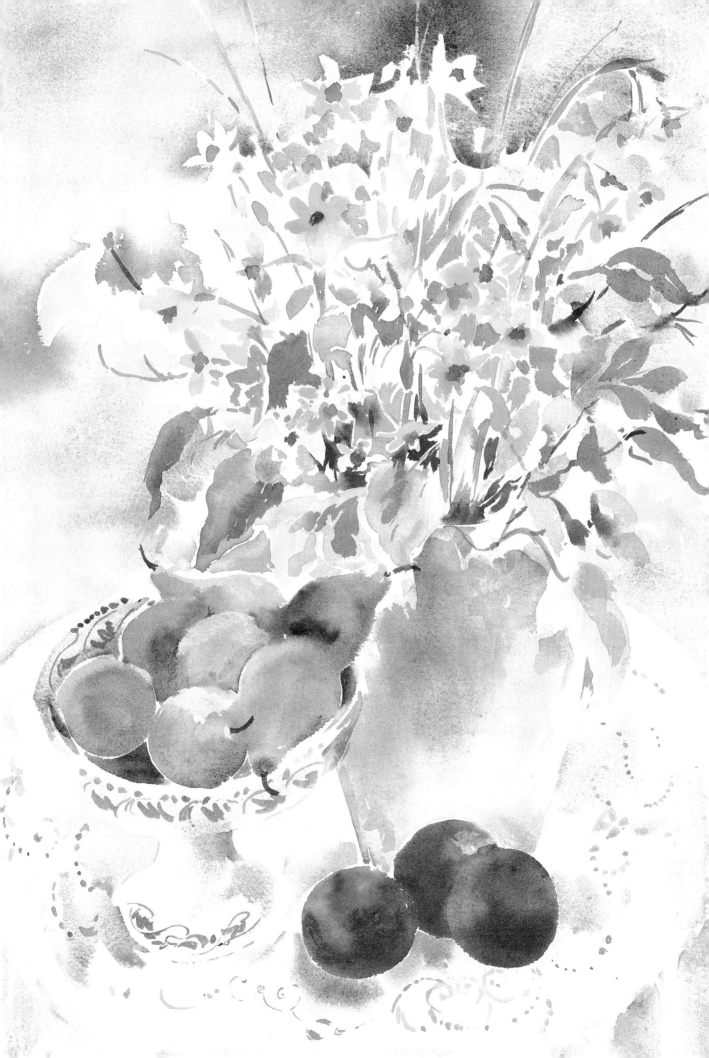

WINTER LANDSCAPES

Painting snow can be exciting. During the course of the day, colours change – brilliant sunshine and snow can combine to give marvellous blue and grey tones. Dark shapes stand out boldly and colours appear brighter and clearer. However, you have to be prepared both mentally and physically for some of the hazards of painting in winter – your water or paint may freeze, and your hands and feet will

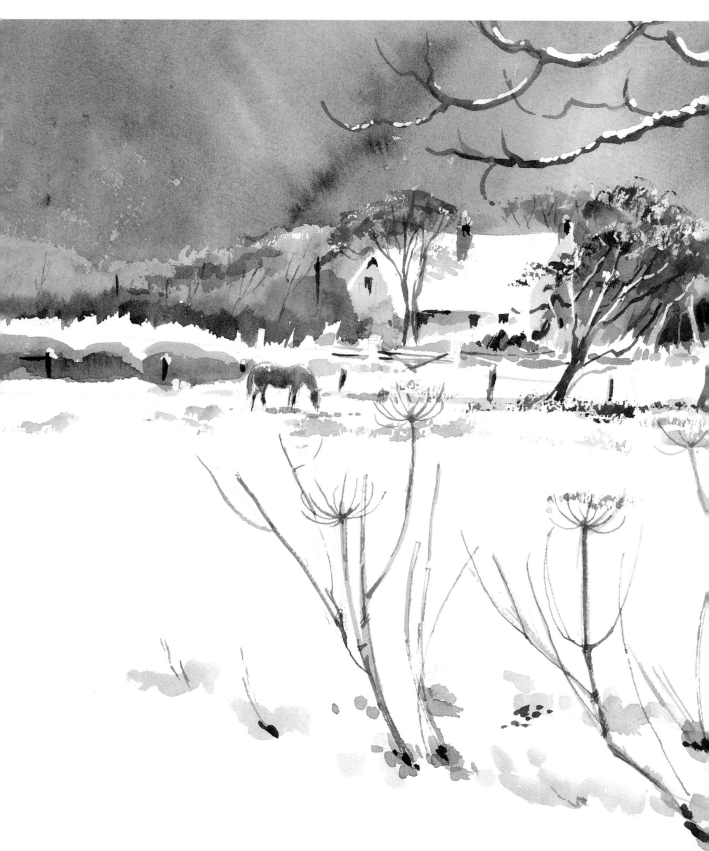

inevitably get cold. Alternatively, you could make small sketches and photographs for reference, then paint your scene at home. If it is not possible to paint outside, try painting from a window. Watercolour is the ideal medium for a winter landscape as you can leave so much white paper and actual painting is reduced to a minimum.

Some artists prefer painting in the winter, as colour and shape can be sharper and more defined. Also, there is not the need to become involved with dense masses of greenery which you find in summer foliage. Working with a limited palette can be challenging, and winter landscapes are ideal for this.

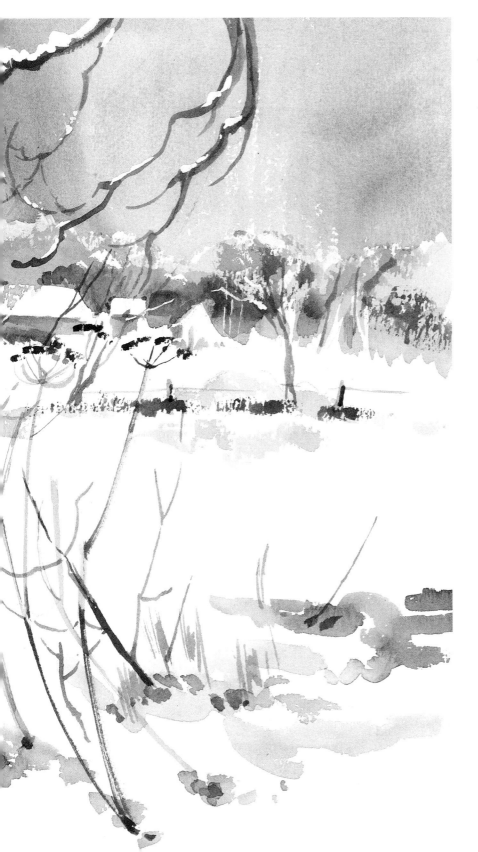

WINTER LANDSCAPE
This painting was developed from a smaller sketch made on the spot. I started with the sky in order to define the farmhouse. The distant trees were allowed to run into the sky (this is not so apparent as later, in fact, the sky was darkened considerably, giving a hard edge to the trees). The rest of the painting was minimal and amounted to drawing with a brush. The colour was limited of necessity

DRIED FLOWERS

GETTING BACK TO DRAWING

Drawing the dried flowers illustrated here helped me to prepare for the free and loose watercolour opposite. I started the picture with a 3B pencil (sharpened to a good point) for the poppy seed-head and the love-in-the-mist seed-head (both of these drawings were enlarged). The achillea head was slightly more tricky as it was a mixture of very delicate and fine fronds of flowers; I had to decide whether to draw everything or to simplify the subject. I chose to simplify it. The spiky thistle-type flower, which was found on a mountain in France, was a very prickly plant to draw. Its main advantage is that it is silver-white and resembles a sun shape, but sorting out all the petals and spikes was

not easy. Drawing makes you think about tonal values and, unless you are drawing entirely in line, a way has to be found to describe tone. If you are very clever, your line can express tone by the use of varied thicknesses of line and calligraphic expressiveness.

Having always had a great love of the economy and directness of black-and-white drawings, I decided to use pen for the drawing of the seed-head. I used a fine fibre pen which gives a reliable and straightforward even-thickness line. In the drawing of the hydrangea, a wash was put in to give a feeling of depth. When using a medium such as pencil, pen or pen-and-wash, you have to be direct; there can be no hesitation about shape or form – you have such a limited medium that there are no excuses for not being straightforward. When some students see their first pen-and-ink drawings they are amazed at their own firmness and decisiveness.

During the summer and autumn I look for flowers, seed-heads and pods that dry well. They are gathered and hung up in my garden shed and used when dry as winter decoration. Both wild and cultivated plants combine well. I particularly like teasel heads and poppy seed-pods, dried leek or onion flowers, wild iris seed-pods, Chinese lanterns, wheat or barley; the list is endless. Even in the depths of winter it is possible to find decorative twigs. Rosehips are very decorative and can add brilliant colour to an arrangement. The most attractive dried flowers are for sale, but if you live in the country, nature can be very generous and many annuals are easy to grow. Among the plants that are suitable for drying are: honesty – silver ovals which shimmer; love-in-the-mist – distinctive heads; sunflower heads dry well and also provide food for the birds; oak apples – these are like punctuation marks; many decorative grasses; sea holly – lovely greys; achillea – plate-like yellow heads; statice – can provide subtle colour.

DRIED FLOWERS ▷
The colours used were mainly earth colours: yellow ochre, raw sienna, burnt sienna, burnt umber and brown madder. The vase was a lovely pinky-cream. I used 140lb Bockingford 30 × 20in (762 × 508mm) and sketched very roughly the positions of the main shapes. Then I washed in the background, leaving white spaces for the honesty. The board was tipped and tilted to get the wash to dry evenly. I worked on dry paper and painted washes on the base and table and then started on the flower heads

108

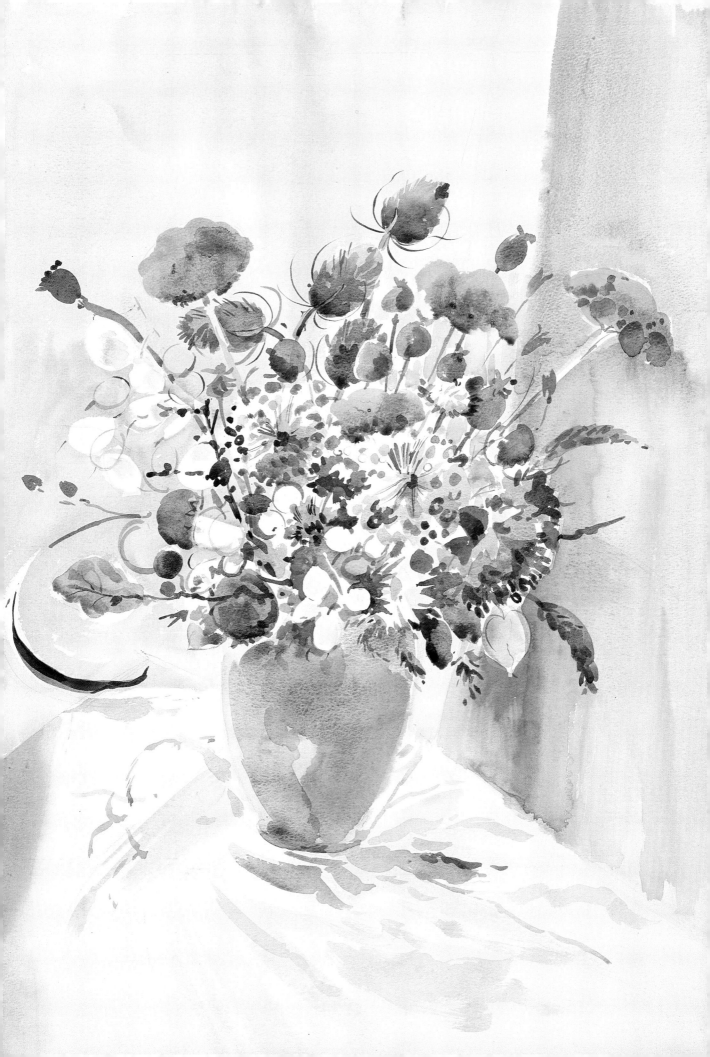

Dried Flowers

HONESTY AND CHINESE LANTERNS

Occasionally it is a change to paint on a tinted ground and it seemed that the light ovals of the honesty would be better represented in gouache. Gouache is opaque watercolour. It is made in the same way as watercolour, but uses a large proportion of medium, including chalk. In this case I added white gouache to my normal watercolour palette, thus obtaining the opaque colour needed on the tinted ground (which was a grey Ingres paper). In using gouache you have the advantage of being able to capitalise on its covering power, not only making use of its ability to obliterate mistakes but building up to a full-strength opaque colour.

The Ingres paper was stretched as it was light-weight. I then proceeded in the same way as for a watercolour painting, but took advantage of white paint for my light shapes. Occasionally you can use gouache on a watercolour painting to enhance certain details – for example, small light leaves or stamens, but it should be used subtly and sparingly.

Coloured papers are often interesting to use, as the tinted ground can provide a middle tone. Various shades and tints are available, from sand and buff to grey and pale blue. You may find coloured paper useful; it is always wise to consider alternative ways of portraying your subject.

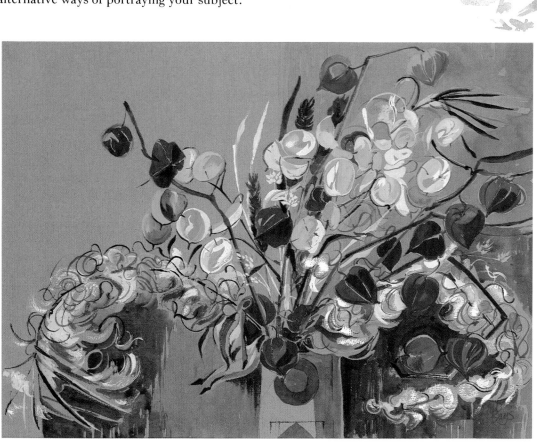

BASKET ARRANGEMENT

It is difficult to have the self-discipline which enables you to hold back and prepare the necessary preliminary work which must go into a finished piece of work. On the one hand, you want to start immediately while that first flush of creativity is on you, while on the other hand you know that careful study repays handsomely. Often, when you have the methods of painting safely acquired, the actual act of creativity always seems just out of reach; this is when your studies can help to clarify your mind and, hopefully, provide the right stimulus and point you in certain directions.

The demonstration picture was painted on an upright easel – not the easiest way to paint – but, if you tilt your easel to allow washes to dry without them running off, it can lead to the kind of freshness and spontaneity that is pleasing. The main difficulty is control. As you don't want your large areas to drain straight off, confidence and control arc the answer – but mine evaporates when I am in front of an audience. I tried to use my brush directly, never concentrating on any one part but moving over the area of painting fairly quickly. The limited palette (earth colours and green) helped a lot. I had also made a preparatory painting which gave me confidence.

111

WINTER
BULBS

It is possible to provide flowers to paint throughout the winter and to continue your garden indoors. Whether you are an industrious gardener or not, most people grow some bulbs to bloom indoors. Narcissi, hyacinths, crocus and daffodils are the most popular, but the most striking is the amaryllis. Freesias are very delicate but difficult to grow indoors, so I buy mine at the florist's.

▷ AMARYLLIS – APPLE BLOSSOM (HIPPEASTRUM)

This winter-flowering bulb is the most striking of indoor flowers. It is not difficult to grow and is a delight to paint. I'm sure that the flower opened while I was painting it. In fact, the painting here is a sequence, which was started one day and continued the next. It is a careful drawing with delicate tints. Do not forget that the stamens and pistil are light against the darker centre – this could be the time to use masking fluid

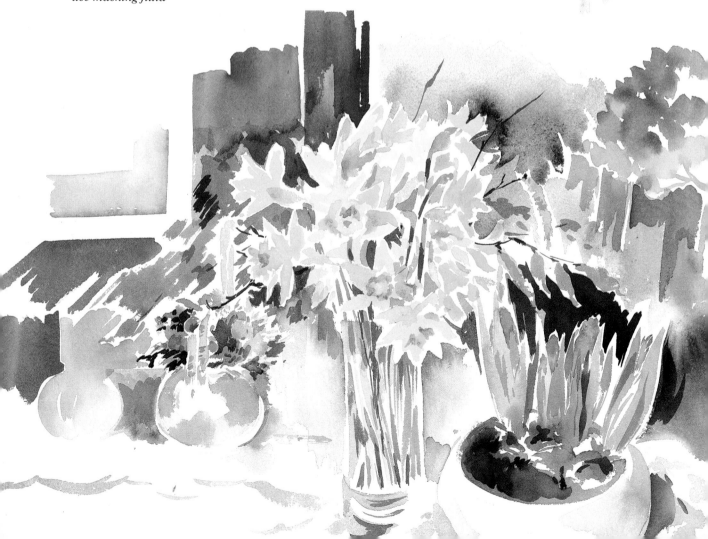

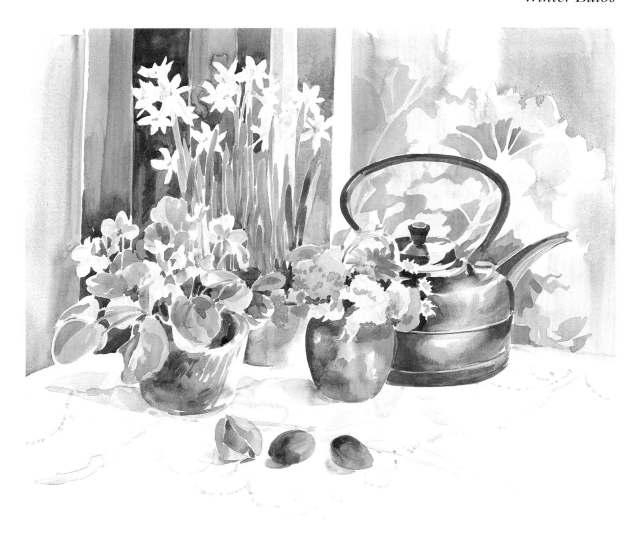

△ *NARCISSI*
This was a carefully arranged group against the window. The paper-white narcissi appeared suddenly and shot up, so there was no time to lose in starting the painting. As the narcissi were white, it seemed appropriate to place them against a dark background. The curtain and window were helpful in providing some depth to the composition. The kettle was used as a darker shape to balance the curtain. The paper used was Fabriano 140lb Not which has a smooth surface and is not so conducive to free-flowing washes

– an interesting change from a more rugged paper. Some of the drawing in this painting was done carefully and many of the small shapes needed precision. The only colour not normally in my palette was the mauve which I used for the African violets.

When painting in oils, it is usual to add or subtract certain parts of the composition by overpainting. With watercolour, of course, this is not possible, so you have to be more or less right from the start. A certain amount of washing out can take place, but often the surface of the paper is disturbed

◁ *DAFFODILS AND HYACINTH*
Late in the winter, daffodils appear in the flower shops and catkins may be seen on the hazel bushes. A warm room will persuade the catkins to come out. This painting was put straight in with the brush and there was no pencil drawing at all. It was painted at night, the light source creating odd shadows and effects. Painting in this way makes you concentrate on essentials as you do not have the time to experiment

WINTER VEGETABLES

Whether you are a gardener or not, most people appreciate the value of winter vegetables. The crisp coldness of celery and watercress for tea on a November evening is a pleasure indeed. The richness and clarity of the colours of naturally grown vegetables often surprise artists. The cool greens of leeks and the subtle cream of parsnips, and the delicate pinks of turnips are ideal for watercolourists. Even the potato can surprise you by its variety of colour. Cabbages are delightful to paint and often look like large green roses. Swiss chard is easy to grow but a challenge to paint – you certainly have to know your greens!

Some winter vegetables have very subtle colouring, and if you are contemplating painting turnips, swedes, parsnips or any root vegetables, it is wise to consider how you arrive at these pale and earthy colours. Neutral colours can be derived from your primary colours – that is, red, yellow and blue; mixing any two complementary colours together will achieve a neutral tint which can be adjusted by the addition of one of the primary colours to become a pinky-grey or a bluey-brown, for example, according to your need. In fact, you can mix more or less any colour you require from these three.

CELERY AND SWEDE

This simple still life was left arranged on a bag, and the tomato was added like a full stop to a sentence. It was painted on Fabriano Not paper 140lb and drawn with a pencil almost to life size. With this precise subject, a light pencil indication is often necessary. The swede was painted first and it was interesting to note its dark and light sides, and how the celery created these tones behind the swede. My normal palette was sufficient to produce the colours necessary and, as usual, it was a question of working from light to dark, particularly on the celery. I enjoyed the highlights on the tomato, and created them by washing out and blotting. There was a considerable amount of adjusting, particularly to the celery, as the leafy part was very full and complicated, but on the whole it was a pleasant subject to tackle.

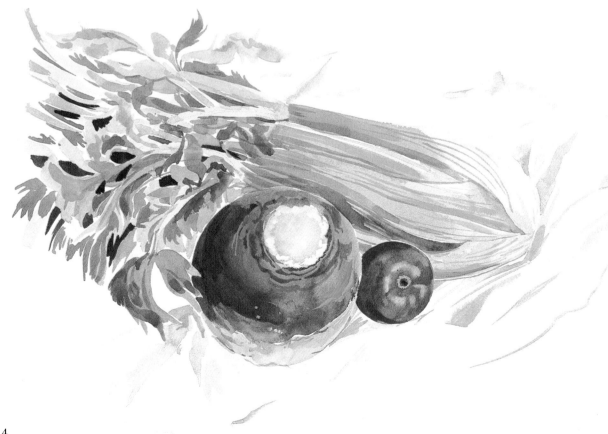

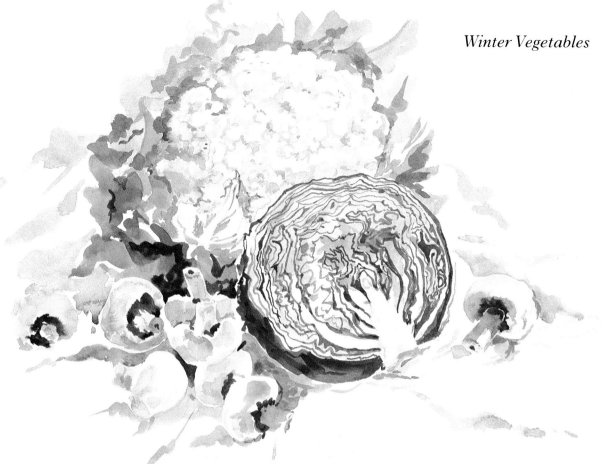

RED CABBAGE, CAULIFLOWER AND MUSHROOMS

How decorative red cabbage is! The patterns formed by the cut surface must surely give inspiration to many designers. Enlarged, it could be a starting point for an abstract painting. Nature is very generous with forms which sow the seeds of ideas for not only painting but for all kinds of decorative work. Cut fruit and vegetables are rewarding to paint. The cauliflower, with its repeating whorls of florets is similar. In this painting, I was thinking of contrasts, particularly of colour. The paper was Fabriano 140lb and the palette was my normal palette without any additions. Although a light pencil drawing was used as the initial guide, it was not absolutely necessary. The painting was finished in a looser way with the painting of the mushrooms, but obviously care had to be taken over the red cabbage which was completed before the cauliflower.

BRUSSELS SPROUTS

Brussels sprouts are handsome plants generally, although mine seem to be afflicted with white fly and have been eaten by caterpillars. Although they are not of first-class quality, they provide a useful standby when I have extra guests for dinner. Another exercise in portraying green, here I started

with a basic light green wash which was then worked into with darker greens to form the veins, etc. Some body colour was introduced laterally to help to define particular features – for example, veins and sprouts. The leaves were floppy and not very attractive, and the plant had to be pinned to a board to prevent it from wilting too much as I was painting in the warmth of the studio.

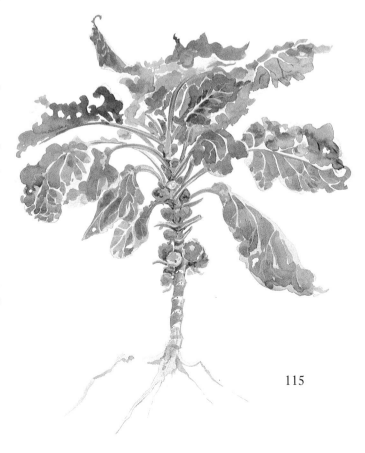

CYCLAMEN AND REFLECTIONS

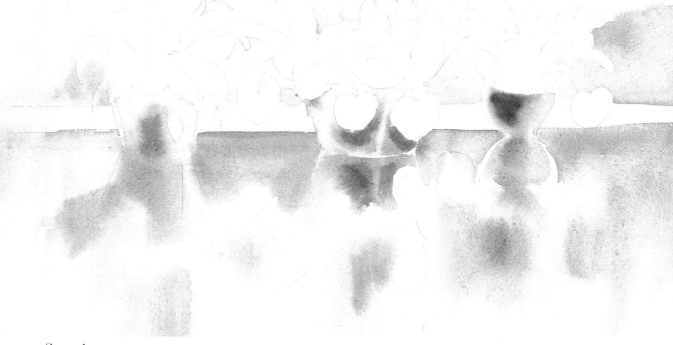

Stage 1

Materials: 140lb Arches Rough; normal palette; No 8 and No 4 sable brushes, large wash brush; sponge.

These delicately tinted cyclamen suggested the subject for this painting. They were placed on a reflective surface and doubled their impact. Flowers on a winter's day can be even more appealing because of the contrast they make to grey and leaden skies. The idea of pale and pastel shades appealed to me, as did the challenge of how to represent the hazy reflections. Various small compositional studies were made.

Stage 1

Draw in lightly with pencil and start by mixing up a light cobalt wash for the sky. Damp the sky area and with the wash drop in the paint to resemble sky and clouds, trying not to go over the white cyclamen. Put a very little alizarin crimson into the wet sky wash at the top of the paper. Mix ultramarine and brown madder. Damp the reflection area and follow the shape of the pots and leaves. Use the same wash for the pots. Indicate the bushes outside the window. Paint all of this in a very loose and damp way.

Stage 2

Continue with the background reflections. Damp flowers and paint a very little alizarin crimson on both cyclamen and reflection of cyclamen. Dry with a hair-dryer, then paint in the horizontal and upright window bar and sills. The reflections can be strengthened if necessary.

Stage 3

Having completed the basic washes, the stalks and major leaves of the plants can now be indicated. The flowers can have further definition by adding a grey tone. The leaves can be worked in light, medium and dark tones of green. As you work on the potted plants, the colours can be repeated in the reflections.

Stage 4 (overleaf)

It can be seen from the previous stages that there has been a progression from light to dark, and this can be further carried on until the painting is considered finished. The darkest tones will give the painting definition and sparkle. The final touches are the red centres of the cyclamen (using alizarin crimson) and the yellow eyes of the African violet.

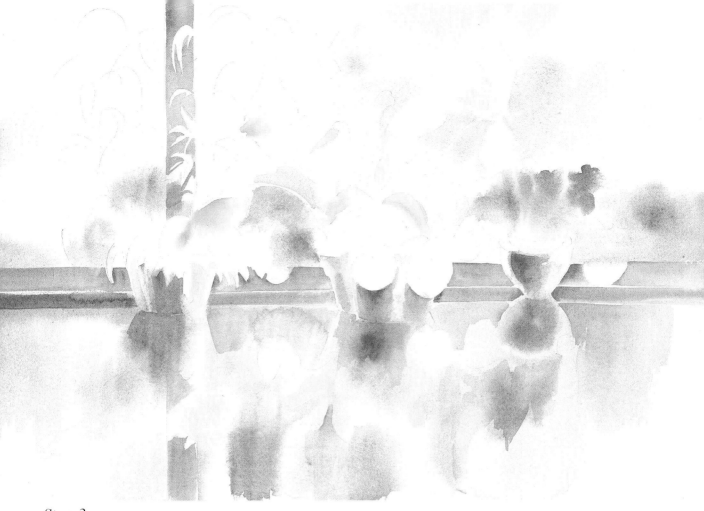

Stage 2

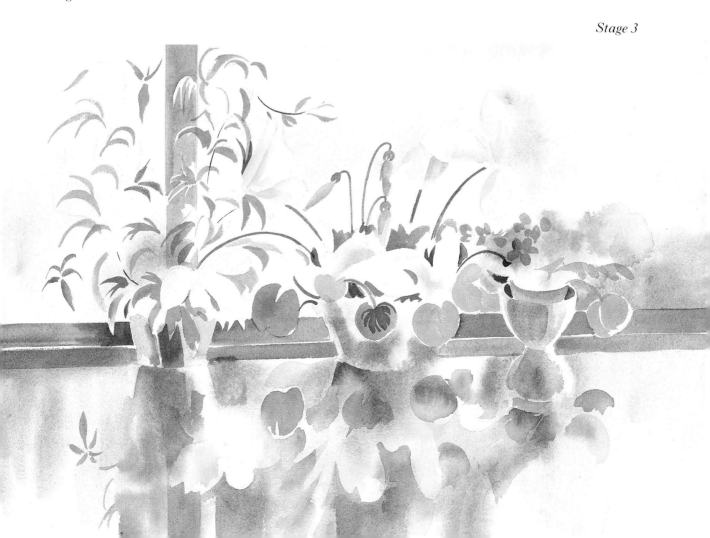

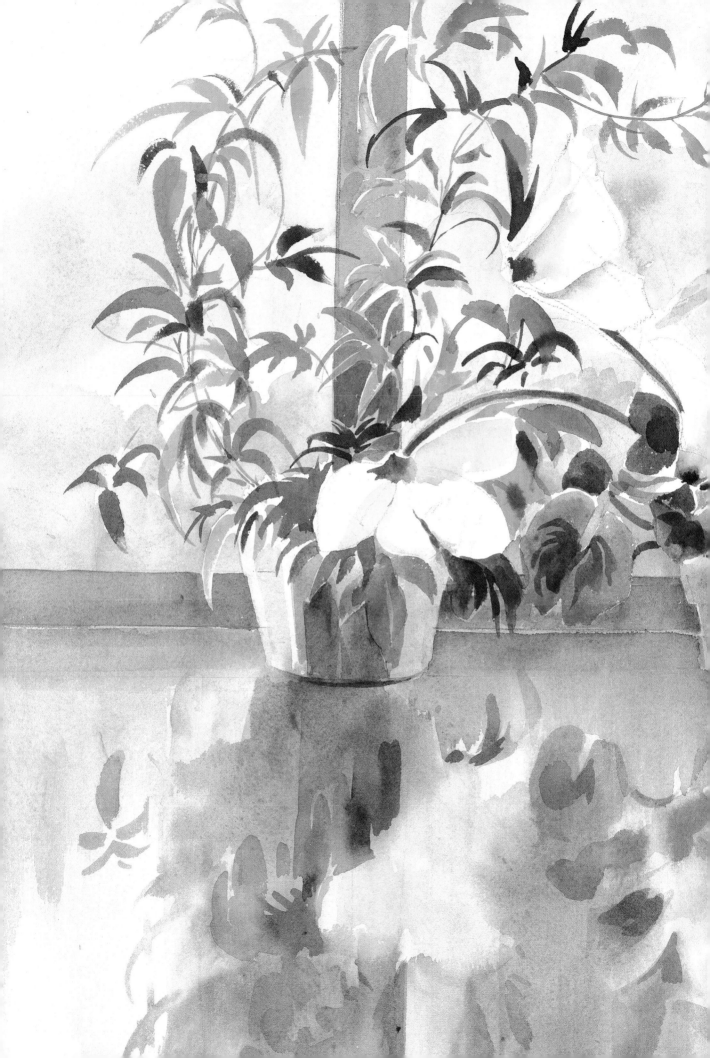

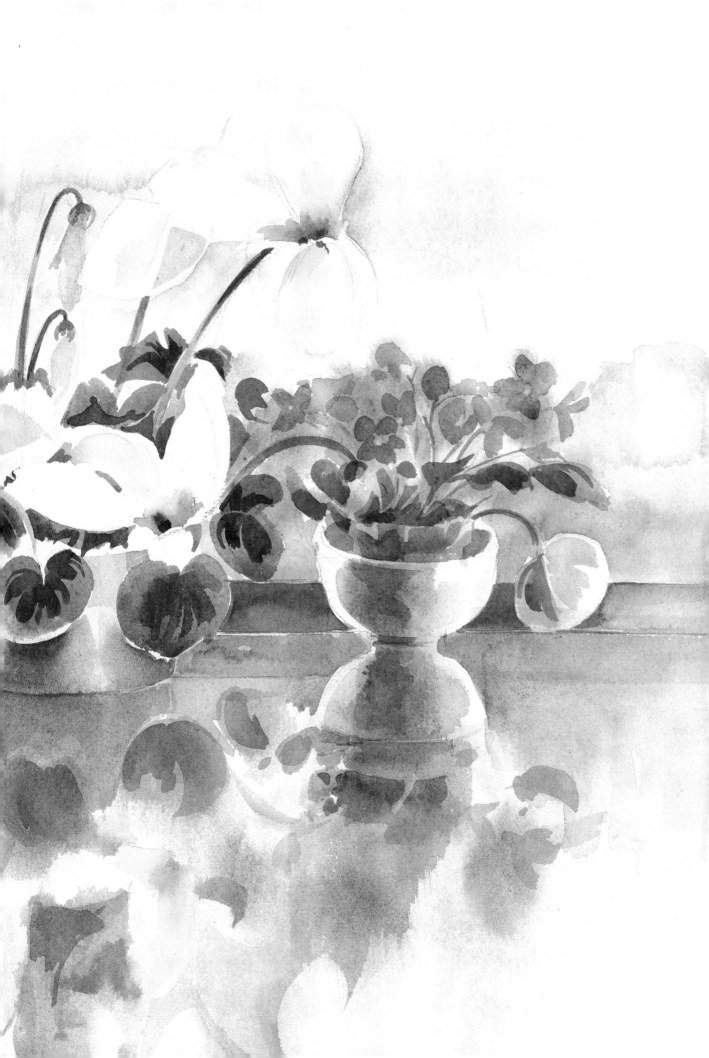

EARLY PRIMROSES

Two paintings of primroses are shown here, both of which were painted indoors.

Primroses can be seen as a sign that winter is almost over and that spring is waiting around the corner. Each year I determine to paint primroses and make a great effort to do so, at what is often a difficult time of the year, when it is nearly impossible to paint outside. Most flower shops sell primroses, but the more delicate variety are only to be found growing in the wild and they should not be picked. If you can, set up a still life using shop-bought primroses.

Having your own studio is a great advantage, especially one with space where you can leave your still-life subject undisturbed. But with small subjects, setting up on a tray can be just as successful. You will need a stiff piece of card for a background (which could even be painted to resemble sky) and your natural subject should be arranged in front. I keep a collection of stones, pebbles and shells, natural wood, small branches, etc to create a natural-looking still life. Dead leaves are easy to find and you can always dig up a clump of grass to add to your creation. You may even become more interested in the clump of grass (as Dürer did) than in the subject you intend to paint.

PAINTING PRIMROSES

Primroses are such enchanting flowers, with delicate stalks and pale blooms, but you wonder how to start. Working on Arches 140lb Not paper stretched, 20 × 15in (508 × 381mm), I painted the general mass of flowers using a pale wash of lemon yellow to get the general flow and drift. There was also plenty of grass and vegetation. This was a large clump of primroses and as it was a warm day they seemed to be falling in all directions. One of the main characteristics of primroses is that they have very delicate and long stalks, unlike the cultivated primulas and polyanthus. They also cling to banks in inaccessible places. My general thought on painting this was that is was a difficult subject and it would be easier to paint a small controlled bunch in a pot

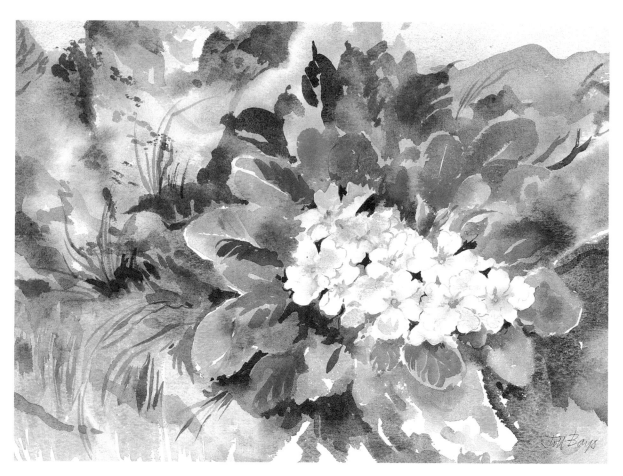

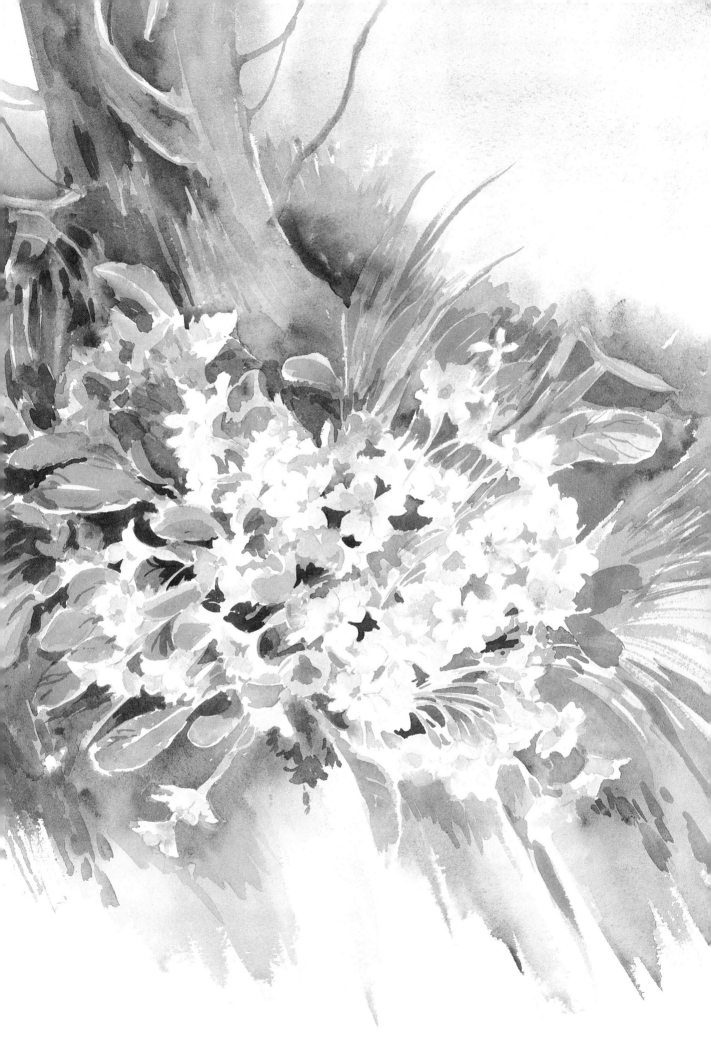

PROBLEMS WITH WATERCOLOUR PAINTING

Most artists know when something is wrong with a painting they have completed, but they can't always work out what it is. The most common faults are as follows:

1 The painting is too pale and washed out.
2 The correct colour has not been achieved.
3 The colours are muddy.
4 Insufficient colour has been mixed.
5 There is a lack of tonal contrast.

If your paintings are pale, you are using too much water and not enough pigment. Practise mixing and matching colour to the subject, which should correct an inability to achieve the right colour. Many students who are starting out make colour charts or swatches to help them. The charts and swatches should contain both pure and mixed colour, which should help a great deal. Remember to name your colours and mixes. There are many differences between various yellows, reds, pinks and blues, and it is wise to have a working knowledge of these. As you become more experienced,

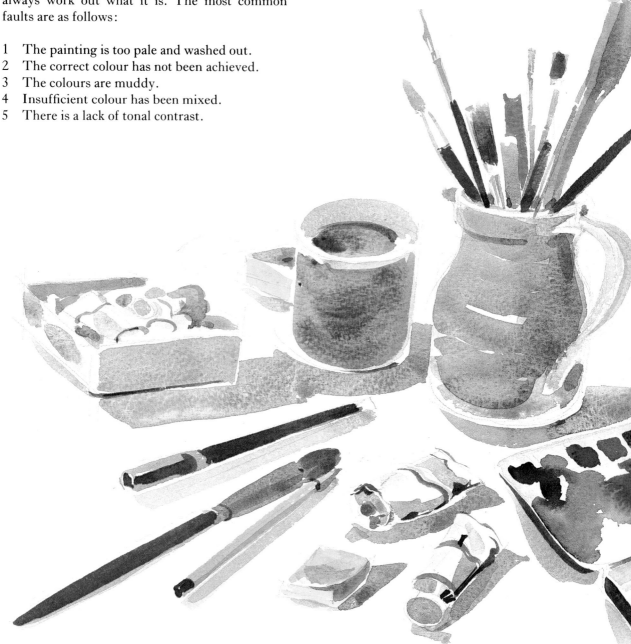

you will find yourself asking questions such as: 'What colour would I use for the geraniums?', 'How do I mix that grey?', etc.

If your colour is muddy, it is probably caused by dirty water, dirty brushes, or a dirty palette. Try to use pure colour, and either achieve your result by overlaying or dropping in paint – that is, mixing on the paper. Don't mix more than two colours together; three will certainly create a muddy effect, which, while not desirable, can have its place, but only in absolute moderation (and then only for landscapes). (Edward Wesson said, in answer to a

question while he was demonstrating, that he had nine colours in his palette, the ninth being mud.)

Green is particularly vulnerable to becoming muddied, and care must be taken to achieve the right degree of brightness, especially when you are painting grass.

If your painting appears lifeless and dull, check the previous faults and then consider your composition and maybe subject. The ability to judge if you have enough colour for a particular purpose comes with experience. Obviously, if you have a large area, mix plenty of colour using larger containers if necessary. Speed is often helpful, too. If you have used a certain colour or simple mix of colour and your paint is fluid enough, you will be able to continue, as long as you don't spend too long mixing up your colour and allowing your first wash to dry. I often meet people who say that they haven't painted for a long time (even maybe a year) and who find it difficult to judge the quantity of colour they will need. Any skill has to be practised, preferably every day, in order to be proficient at it, but bad habits can be overcome and proficiency increased.

If I am not happy with a painting, I have a personal check-list, which is line, tone, texture, pattern. I check the linear content, which could be the quality of drawing and of technique. Are the lines and brush-strokes taut or flowing, not wobbly or broken? Tonal quality is next, and you should ensure that the painting reads well and makes sense tonally. With texture there should be a variety of marks – that is, the subject should be represented correctly to show that it is smooth or hard, etc, so that the surface has a lively quality. Pattern is more difficult to explain. We know that a pattern consists of repeating shapes, and in the case of a painting it could be the repetition of some shapes or colours or the way the subject is portrayed on the picture surface; also, composition is very relevant. Sometimes you can see a pattern in the way leaves fall one on the other, or the pattern made by individual flower-heads – for example, the centre of a sunflower. Pattern can be reassuring in a painting, but moderation is important. It is easy to write about but not easy to achieve perfect results.

Lack of tonal contrast is difficult to correct and requires the ability to see tones. Earlier I wrote about painting tonally and suggested the use of a range of greys from black to white. Check the darkest part of your subject in your painting and note the lightest part, then think of achieving a light-to-dark and a dark-to-light pattern.

EXHIBITING YOUR WORK

Exhibiting takes courage and energy, but to see your work hanging in a frame on show can be a thrilling experience. Your paintings may be exhibited alongside the work of other artists, or you may have a one-man exhibition. But whichever way your work is exhibited, it is exciting. Your painting seems removed from you and it is possible to view it objectively, which is very helpful. The frame alone will help to set the painting apart. It will be possible to ask yourself, 'Does the painting fade away?', 'Is it readable?', 'Is the composition right?'.

When you have decided that your painting is acceptable for showing, it is always a good policy to make sure that your presentation is as good as possible. Good presentation is often the difference between the amateur and the professional, and this doesn't only mean good framing. A good straight edge (a steel rule) and a really sharp knife will trim ragged edges. A portfolio will keep your work flat and clean (never roll a picture). A few minutes spent cleaning off unwanted spots or blotches can help, as can a professionally printed name card.

There are many art groups, clubs or societies which it is possible to join with a view to working with other artists or taking part in discussions or demonstrations. Such groups usually make trips to art exhibitions, museums, etc and often offer the opportunity to exhibit with other members. This is a good introduction to the running of art exhibitions, which can include selection, hanging, stewarding, etc. Should you ever decide to exhibit alone, this will be a good initiation for you.

124

Places to exhibit your work can vary from one's own home to public halls, foyers, libraries, schools, etc. Occasionally there are places which are delighted to display your paintings on their walls: shops, cafés, hospitals, building societies, etc. If you hang your own paintings, it pays to be practical and to have in your equipment a bradawl, a small hammer, pliers, scissors, small nails, screw eyes and a strong nylon string. A measure and chalk are also useful. The wall or exhibiting surface is important and it is a good idea to inspect the premises in advance. Lighting is all important, as is labelling and cataloguing. This need not be elaborate and can easily be done by hand, if necessary. A short note on the artist or club is always interesting. A visitors' book is useful so that you know who has viewed your work. An invitation list and mailing list are also important.

Should you decide to exhibit in such places as galleries or open exhibitions, the procedure is slightly different. Commercial galleries have to be approached, which is best done by appointment. Should they decide to show your work, you will have to state a price and the gallery will deduct a percentage, usually a third, but it could be less or much more. You are usually expected to provide the frame; the gallery provides the space and any publicity.

An open exhibition is one in which you can submit work for selection. There is usually a submission fee and, if your work is hung, a hanging fee. This can be an expensive procedure. Open exhibitions are often held in big cities or regions and are arranged by nationally known groups. You will be told the submission days and place, and you should apply to the Secretary. There is no doubt that to hang your work with that of the members of a major society can be thrilling, but don't underestimate the time and energy it can consume. The percentage taken on a sale is often less than a commercial gallery will take.

Mounting and framing your work is important, and good framing can almost transform a painting.

A great deal of thought and consideration can go into choosing the right moulding, of which there are many different kinds. Before involving yourself in expense, study the way watercolours are framed by visiting galleries, etc. Most framers will be happy to show you a selection of mouldings and to advise you.

Apart from commercial framing, there are various kinds of do-it-yourself methods, which can be cheaper. Some framers will supply ready cut mouldings to size, glass and hardboard can be purchased, and mounts are not impossible to cut, particularly with the mount cutters which are available today.

Mounts are interesting and can greatly enhance a painting. You may have difficulty in choosing from the large variety available. If you choose one of the many coloured mounting boards, the colour should pick out one of the colours in the painting; it should not be too obtrusive, however. A coloured mount can be softened with a white inset. There are different thicknesses of card and the cut edge could be coloured or covered. Widths of mounts are debatable; some artists favour an even width all round and others prefer the mount to be deeper at the bottom than at the sides or top. Wash lines used to be in favour and required ruling pens and practice, as well as T-squares and accuracy.

Alternatively, many artists make their own mounts, cut the mount and mouldings, and fit them together with glass and backing boards.

Mounting board is available in various weights and sizes, and in many colours, and sometimes can have a surface texture. Paintings can be protected by using acid-free boards. Framers are continually finding novel ways of enhancing paintings. Some favour double mounts, while others prefer wash lines. Some suppliers will provide ready-cut mounts, rectangular and oval, as well as complete framing systems. Clip frames are a cheaper alternative, but your work should always be protected by glass or a glass substitute.

POSTSCRIPT

To paint well and successfully, courage is needed. The majority of would-be watercolourists have some knowledge of the medium and some knowledge of drawing, but they lack determination and the courage to continue when things start to go wrong. Most people need a prod or two or some sort of stimulus. The more you look at other artists' paintings, books, prints, or visit museums and galleries, the more informed you will be about subjects, materials and methods. The more you talk to other artists the better, and if you have the determination you will paint and paint, and moreover enjoy it more and more, no matter how difficult it becomes or how tired you get. Improve your drawing and master the technique. Subjects abound everywhere. Don't acquire too many preferences but do try everything. If your drawing and approach is tight, loosen up by working in a different way; if you are too slap-dash, make a conscious effort to become more careful.

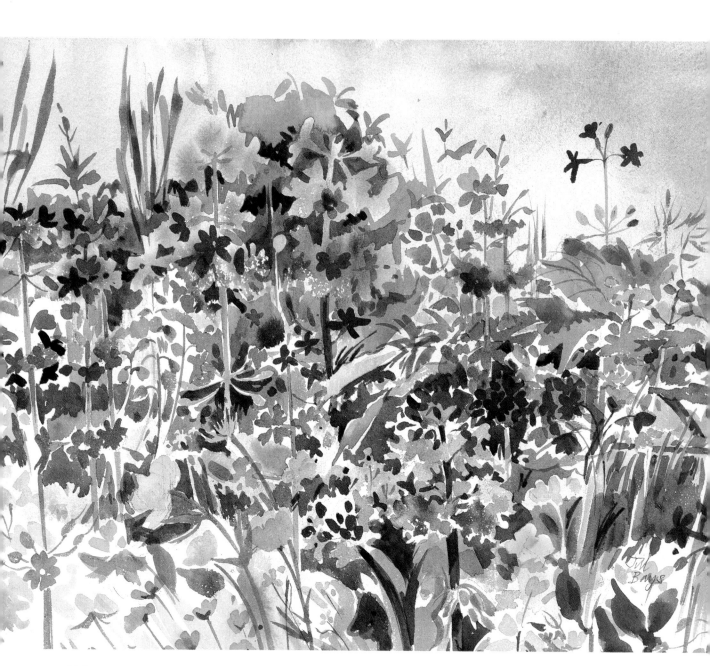

GLOSSARY

Alizarin colours These were introduced in the 1860s and are a coal-tar derivative. Alizarin colours range from crimson through violet to a reddish brown (brown madder). They are slightly blue in tone, but this is not obvious to any extent. The alizarin colours replace the old crimson lakes and madders.

Bockingford paper A heavier weight watercolour paper at a reasonable price. However, it is not available in hot-pressed or rough surfaces.

Broken colour Neutral colours, or those which are made by mixing primary and secondary colours together.

Calligraphic A description given to lines which resemble beautiful handwriting.

Cartridge paper A lightweight drawing paper which will cockle if water is applied.

Complementary colour Colours which are opposite on the colour wheel – that is, red-green, yellow-purple and blue-orange.

Composition The way objects are arranged on the picture plane.

Ellipse A circle in perspective.

Form The shape and solidity of an object.

Gouache An opaque paint, unlike watercolour, which is transparent but also uses water as a medium.

Hake brush An oriental flat brush in various widths, probably made of goat's hair. It is soft and good to use for large washes, and is enjoying a certain popularity.

Imperial A paper size 22 × 30in (559 × 762mm), it is now largely superseded by paper in international sizes. Half Imperial is half of this large sheet.

Ingres paper A tinted paper often used in pastel painting.

Local colour The actual colour of an object unaffected by light or shade.

Masking fluid A rubberised solution used in resist techniques, whereby light shapes painted with the fluid can then be painted over with another colour. The masking fluid can be removed, revealing the light shapes.

Mount A mount is used to protect a piece of finished work. It is made usually of strong card and has a window cut in it to show the painting.

'Not' paper A paper whose surface is neither rough nor smooth.

Perspective Drawing solid objects on a flat plane to give the impression that they are in space.

Pigment The colouring matter used in the manufacture of paint.

Primary colours Red, yellow and blue.

Resist Used to describe substances which are resistant to water – for example, gum and wax.

Spatter A random way of expressing texture on the paper, often achieved by running a finger across a stiff brush and creating dots and spots of colour.

Stretched paper Paper which has been dampened, fixed to a board and allowed to dry, thus making it less inclined to cockle.

Support The board used to support your paper while you are painting.

Texture The character of a surface in a painting – for example, smooth, rough, etc.

Thumb-nail sketch A small sketch used to initiate a painting – often in pencil and about 3 × 4in (76 × 102mm).

Tint Full-strength colour diluted with water.

Tonal values The values in a painting which are gradated from light to dark.

Viewfinder A small piece of card with a cut-out rectangle, through which to view your subject (thus obliterating the surroundings).

Viewpoint The place from which the subject is viewed. It can be above or below the subject, as well as in front, but should be constant.

Warm and cool colour A description given to colour which favours either red (warm) or blue (cool).

Wash Watercolour with the addition of water applied in an even manner to create a flat area of colour.

Watermark Often seen on good watercolour paper to indicate the maker's identity. Work on the side on which you can read the mark.

Wet into wet A description of a method of painting where wet paint is mixed with further wet paint, making the colour diffuse and run.

INDEX

Numbers in **bold** indicate illustrations

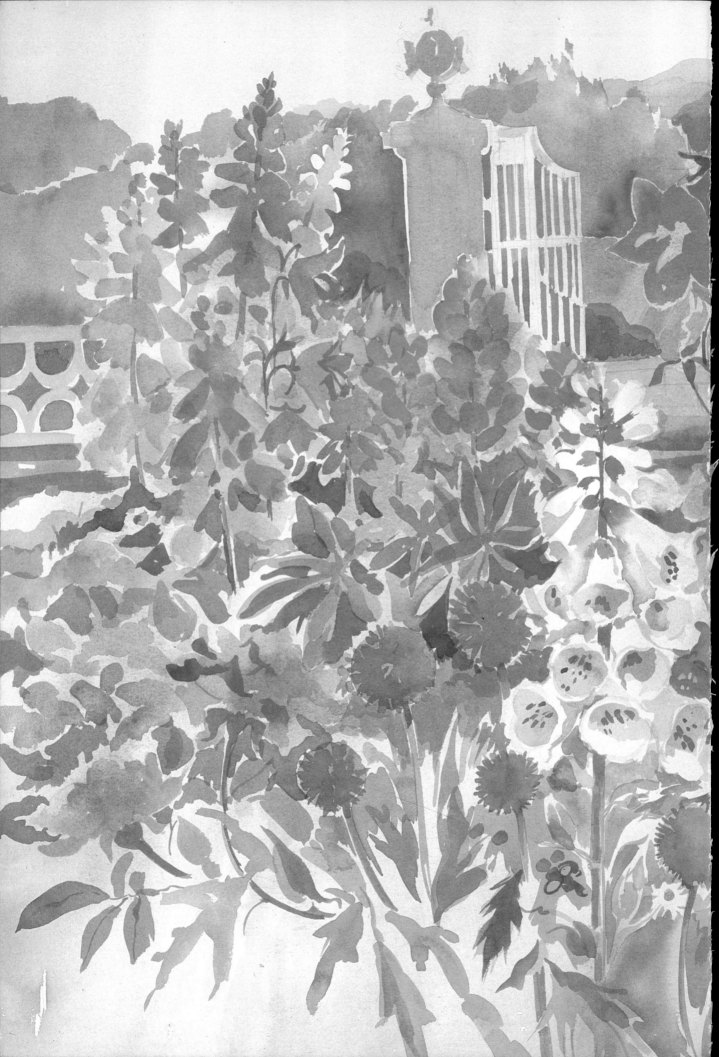